IMAGES
of America

ALONG THE
SCHUYLKILL RIVER

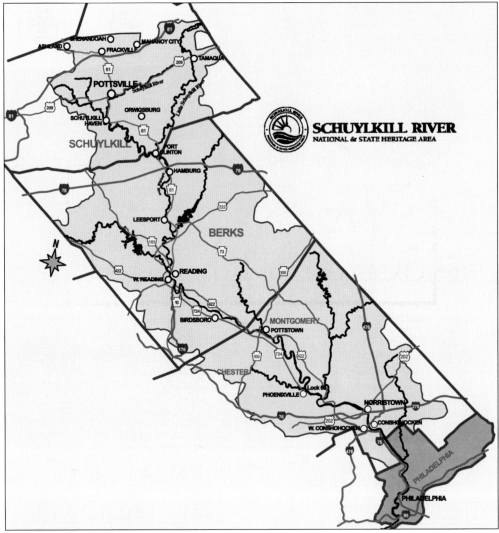

This map shows the Schuylkill River watershed. The river, outlined in dark gray, stretches from Schuylkill County to Philadelphia. (Courtesy of Schuylkill River National and State Heritage Area.)

On the cover: A group of canal workers pose before the lock tender's shanty at Fairmount Lock in Philadelphia. The lock once sat directly across the river from Fairmount Water Works, which can be seen on the left. This picture is dated August 29, 1895. The neatly appointed shanty would have been used to store equipment and records for the lock. (Courtesy of Philadelphia Water Department.)

IMAGES
of America

ALONG THE SCHUYLKILL RIVER

Laura Catalano and Kurt D. Zwikl

ARCADIA
PUBLISHING

Published by Arcadia Publishing
Charleston SC, Chicago IL, Portsmouth NH, San Francisco CA

Printed in the United States of America

Library of Congress Control Number: 2008941573

For all general information contact Arcadia Publishing at:
Telephone 843-853-2070
Fax 843-853-0044
E-mail sales@arcadiapublishing.com
For customer service and orders:
Toll-Free 1-888-313-2665

Visit us on the Internet at www.arcadiapublishing.com

Dedicated to the Schuylkill River National and State Heritage Area staff: Susan Fordyce, Robert Folwell, Cindy Kott, Dolores Bonjo, Tim Fenchel, Kara Wilson, and Dwight Powell

CONTENTS

ACKNOWLEDGMENTS

This book could not have been written without the help of many people who generously shared their photographs and knowledge and in some cases spent hours assisting us. Special thanks to Adam Levine, archivist for the Philadelphia Water Department (PWD), and to Deb Sting of the City of Philadelphia's department of records, which generously provided both permission and high-resolution images from the Philadelphia City Archives (PCA). These and thousands of other photographs are available online at the PhillyHistory Web site. Thanks also to Betsy Daley of the Schuylkill Canal Association (SCA); John R. Ertell, president of the Historical Society of the Phoenixville Area (HSPA); Charles Miller of the Amity Heritage Society (AHS); Jack and Brian Coll; Joseph Collins and Richard Galie of the Conshohocken Historical Society (CHS); William C. Brunner of the Spring-Ford Area Historical Society (SFAHS); Doris Callow of the Limerick Township Historical Society; David R. Kerns of the Pottstown Historical Society (PHS); Ryan Strause of the Leesport Lock House Foundation (LLHF); David Berger of the Hamburg Area Historical Society (HAHS); Jennifer Bowen of the Orwigsburg Historical Society (OHS); Joel T. Fry, curator for Bartram's Garden; Barbara Rusk of the Tricounty Heritage Society (THS); David Derbes of the Historical Society of Schuylkill County (HSSC); Kay Sykora of Manayunk Development Corporation (MDC); Ellen Sheehan of the East Falls Historical Society (EFHS); Tom Troutman of the Lower Pottsgrove Historical Society (LPHS); Thomas C. Keim, township manager of Robeson Township; Rob Armstrong of the Fairmount Park Commission; Linda Wisniewski of the Library Company of Philadelphia (LCP); Jean Wolf, executive director of the Woodlands; Michael Panzer, archivist for the Philadelphia Inquirer; Lynn Tunmer and volunteer Mary Forde of the Philadelphia Zoo; archivist Dona McDermott of Valley Forge National Historical Park; Jean Longo and Karen Lightner of the Free Library of Philadelphia (FLP); Brenda Galloway-Wright of Temple University Urban Archives (UA); Jeffrey R. McGranahan of the Historical Society of Montgomery County (HSMC); Max Butan of the Lower Merion Historical Society; Sime Bertolet, Bill Koch, and Kimberly Richards of the Historical Society of Berks County (HSBC); Mark Major of the Schuylkill County Visitors Bureau; and Charles Marshall of Laurel Locks Farm (LLF). Last but not least, we are grateful to our interns Andrew Majcher and Kevin Wallace, whose initial research made our jobs much easier.

We also wish to thank Erin Vosgien, our editor at Arcadia Publishing, who was always encouraging and unfailingly helpful.

INTRODUCTION

Whoever you are, wherever you live, whatever your ancestry, if you are an American, the story of the Schuylkill River is your story. Key chapters in America's history were played out along this river. George Washington and his army crossed its waters several times during some of the most difficult years of the Revolutionary War. Later the nation's Industrial Revolution was fueled by coal transported along the Schuylkill Navigation System—a system of canals and dams that made the Schuylkill River navigable. Eventually the slow-moving canal barges were replaced by fast-moving trains that followed the banks of the river. The Philadelphia and Reading Railroad (P&R), built also to transport coal, grew so large and so powerful that its rails crisscrossed the country.

But the river's story is deeper than that. It is also the story of the people who hand dug the canal, of the laborers who laid the railroads, of the architects who designed beautiful railroad stations, of the miners who toiled away in dark, dangerous coal mines, of the women who made clothing and Civil War blankets in the textile mills, and of the men who built bridge columns and war cannons in the iron and steel mills that once defined the region. This book was written to give the reader a glimpse into that world, now long gone but the threads of which formed the fabric of life today.

If you could travel through time to the Schuylkill River corridor during Colonial times, what would you see? A region dotted with iron furnaces. During the 18th and 19th centuries, the Schuylkill River area grew into a center for iron production, boasting about 30 furnaces, forges, and iron mines. Beginning in the early 1700s, colonists began settling the region, attracted by an abundance of natural resources. Among those resources were the four materials necessary for producing iron: good quality iron ore; a large supply of limestone, used in furnaces to remove impurities from the iron; extensive forests that provided the blast furnaces with the 600 acres of trees that were needed each year to produce charcoal; and fast-flowing streams and rivers to power the bellows for the furnace.

Those furnaces helped produce basic supplies like nails, horseshoes, and cooking utensils. And, during the Revolutionary War, they supplied the Continental army with cannons and shot.

In the mid-1800s, Pennsylvania became the center of America's iron and steel production, and it remained the steel capital of the world for over a century. Nearly every town and city along the Schuylkill River had at least one steel mill.

Of course, the region also had another resource that eventually proved even more fundamental to the development of the area and the country—anthracite coal. Legend has it that in 1790, a hunter named Necho Allen lit a campfire that, as he slept, ignited an entire cliff on Broad

Mountain, in Schuylkill County. He thus discovered anthracite coal. Whether the story is true, coal proved to be a valuable commodity. By the late 1820s, Schuylkill County was bustling with prospectors and opportunists who dug holes into the hillsides and carried out coal in buckets. Eventually mines were built. But as the demand for coal grew, so did the need to transport it. So the Schuylkill Navigation System was born.

The Schuylkill Canal was built between 1816 and 1825 by the Schuylkill Navigation Company—a group of businessmen who sought to make the shallow Schuylkill River navigable. Its primary purpose was to carry anthracite coal from the coal region, at the top of the Schuylkill River, to Philadelphia. It covered a distance of 108 miles, beginning in Port Carbon, running through five counties, and ending in Philadelphia.

The Schuylkill Canal was actually a navigational system that consisted of a series of dams and canals. The 32 dams created a slack water area for boats in the river, while 23 canals provided passage around changes in water levels. Boats entered and exited the canals through locks, which raised or lowered the boats to the next level. The boats were pulled by mules, walking on towpaths located along the canals.

The Schuylkill Navigation Company, which operated from 1825 to 1917, was hugely successful for many years, primarily because the Industrial Revolution generated a relentless demand for coal. In an effort to better meet that demand, the company enlarged the canal and built bigger boats in 1833. The depth of water in the canals was increased, and a double line of locks was constructed to enable boats to pass in either direction at the same time.

Financially speaking, the Schuylkill Navigation Company was most prosperous from 1835 to 1841. However, it reached its peak tonnage in 1859, when 1,400 boats traveled up and down the Schuylkill, carrying a total of 1.7 million tons of merchandise. About 1.4 million of that was coal, half of which was destined for New York City. Despite that, the Schuylkill Navigation Company had been suffering financial instability since the opening of the P&R in 1842. Floods in 1850, 1862, and 1869 caused tremendous damage and stopped traffic, sometimes for months at a stretch.

In 1870, the canal was leased to the P&R, but the expansion of the railroad eventually led to the demise of the canal. What's more, coal silt that washed into the canal made it impossible to maintain sufficient depth for boats to navigate. Because of that, dam No. 1, in Port Carbon, was closed in 1853, and the section of canal between Schuylkill Haven and Port Clinton was shut down in 1888.

By the end of 1915, only about 30 boats remained in service. A few canal boats continued on the lower part of the river until as late as 1930, after which time the canal was used recreationally, with motorboats, rowboats, and canoes traveling in and below Reading.

In 1949, the bankrupted Schuylkill Navigation Company deeded all its properties to the Commonwealth of Pennsylvania. The state embarked upon the Schuylkill River Desilting Project. By the early 1900s, waste from the coal operations washed more than three million tons of silt annually into the river. In the 1930s, so much silt had accumulated that the river was no longer navigable, and its value as a water supply was threatened.

The Commonwealth of Pennsylvania's desilting project dredged silt from the river and poured it into canal beds and silt basins. The coal was later reclaimed and used in various products, including charcoal briquettes. This major environmental undertaking vastly improved the river. However, it destroyed the Schuylkill Navigation channel, as many locks and dams were buried by silt, dismantled, or simply neglected.

Today there are only scarce remnants of the Schuylkill Navigation System's locks, dams, and canals, although several sites have since been restored for their historic importance and value as tourist attractions.

The canal failed for all the reasons mentioned above but primarily because of competition from the railroads, which were able to travel much faster and carry far more freight than canal barges. In 1833, the P&R decided to cash in on the anthracite coal trade. It established a 94-mile rail line to haul coal from Reading to Philadelphia.

Over the next several decades, the P&R expanded into a major corporation, with lines running in every direction throughout the increasingly industrialized Northeast. By 1870, it had grown to become the largest corporation in the world.

It was not until 1842, however, that the P&R completed a freight and passenger line that stretched from Philadelphia to Pottsville. It was an immediate success. Coal-laden trains were able to make the trip from Pottsville to Philadelphia in five hours, as opposed to the six days required for canal boats. What's more, trains could carry three times more coal than barges. In its peak year, 1859, the Schuylkill Canal boasted 1.7 million tons of cargo. During the same year, the P&R carried over 2.5 million tons.

By 1870, the canal was no longer a serious competitor, and the Schuylkill Navigation Company leased its waterway to the P&R.

In 1884, the Pennsylvania Railroad attempted to compete with the P&R (known later as the Reading Railroad) for the coal trade. The Pennsylvania Railroad built a Schuylkill branch that paralleled the Reading line to Manayunk, Norristown, then onto Reading and Pottsville, and beyond that to Hazelton and Wilkes-Barre. Like the P&R, it offered both passenger and freight service to these areas. However, it was never very profitable, primarily because there was not enough traffic to support two railroads along one route. The Schuylkill branch was gradually cut back, until in 1970 it ran only to Manayunk, and in 1986, it was cut further to Bala Cynwyd. Today most of the Pennsylvania Railroad's Schuylkill branch right-of-way has been turned into the Schuylkill River Trail.

The Reading Railroad continued to run profitably through to the 1950s. However, after World War II, oil and gas became the nation's primary sources of fuel. The demand for anthracite coal diminished, and, with that, the Reading Railroad went into decline. In 1971, it claimed bankruptcy, and the rail lines were conveyed to Conrail in 1976. The Norristown regional rail line of the Southeastern Pennsylvania Transportation Authority (SEPTA) still follows the former Reading Railroad right-of-way, and freight trains continue to run along much of the remaining line.

While the canal and railroads are key elements of the Schuylkill River region, its history includes a broad range of people and events. Consider how many of America's firsts happened here. The country's first public water supply was created when Philadelphia's Fairmount Water Works was built on the banks of the Schuylkill River. The first park established to protect a water supply, Fairmount Park, also happened here. America's first botanist, John Bartram, lived along the shores of the Schuylkill River, and the first vineyard was founded by Peter Legaux. The Philadelphia Zoo, America's first zoo, was built here. Some historians consider the Market Street Bridge the first covered bridge in the country. The first tunnel in North America was built along the Schuylkill Canal, and the first iron truss bridge was devised and constructed in Pottstown.

Today many people think of the Schuylkill River as nothing more than the body of water they pass alongside or cross over on their daily commute. It is, in fact, a source of drinking water for 1.75 million people. But as you peruse the photographs in this book, we hope you will see that the riverbed holds more than just water. It holds the very history of our nation.

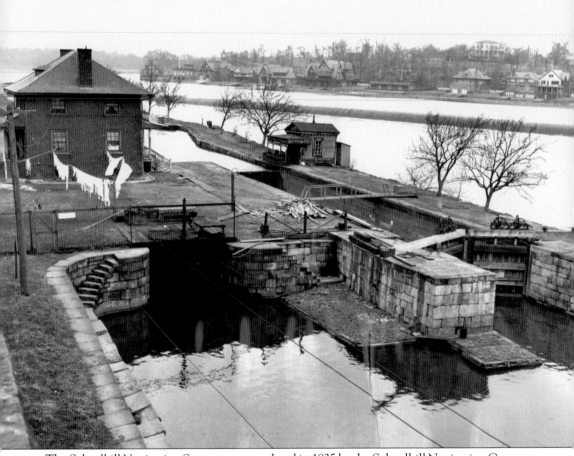

The Schuylkill Navigation System was completed in 1825 by the Schuylkill Navigation Company in order to carry anthracite coal from Schuylkill County to Philadelphia. It stretched 108 miles and consisted of a series of dams and canals. This 1940 photograph shows the Fairmount canal lock across from Boathouse Row, shortly before its demise. The lock tender's shanty, center, is the same as that on the cover. (Courtesy of Philadelphia Newspapers Incorporated.)

One

PHILADELPHIA

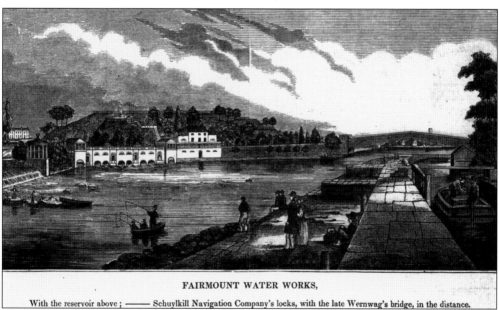

FAIRMOUNT WATER WORKS,

With the reservoir above ; ——— Schuylkill Navigation Company's locks, with the late Wernwag's bridge, in the distance.

Fairmount Water Works in northwest Philadelphia was considered a technological wonder when it was built in 1815, making Philadelphia the first American city with a safe municipal water supply. This 1843 wood engraving shows the waterworks, the reservoir on the hill, and, to the left, Fairmount Dam. To the right is Wernwag's Bridge (also known as "Collosus"), built in 1812, and the locks of the Schuylkill Navigation Company. (Courtesy of PWD, from the Jay Snider collection.)

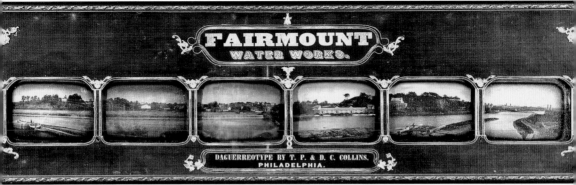

This *c.* 1846 six-plate daguerreotype by T. P. and D. C. Collins is one of the first multiplate panoramas ever made and perhaps the earliest photographic image of the Schuylkill River. The panorama shows, from left to right, the canal locks, Fairmount Dam, the Fairmount Water Works buildings, and, to the far right, the Wire Bridge, built in 1842, which replaced the Wernwag's covered bridge seen in the earlier illustration. Originally the steam engines pumped water to the reservoir located atop nearby Faire Mount. By 1822, Fairmount Dam was constructed and a mill house was built, so that giant waterwheels operated pumps. (Courtesy of Franklin Institute.)

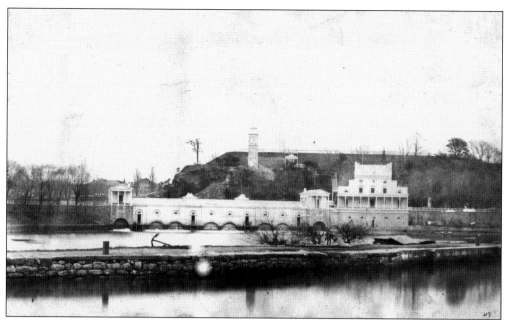

In 1855, Fairmount Water Works was one of America's most popular tourist attractions (second only to Niagara Falls) and remained so for most of the 1800s. Fredrick Graff, chief engineer of the waterworks, housed the machinery in artistically designed neoclassical buildings. A garden, fountains, and paths added to the attraction. In an 1842 visit, Charles Dickens called it "a place wondrous to behold." (Courtesy of LCP, photograph by James E. McClees.)

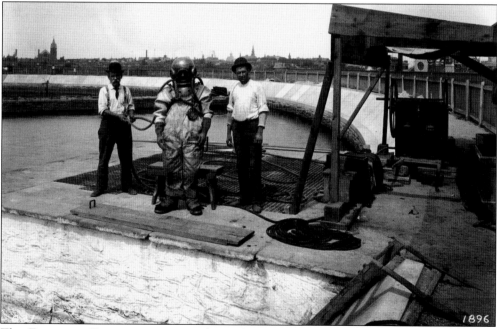

The Fairmount Reservoir once sat above the waterworks on land now occupied by the Philadelphia Museum of Art. This photograph shows the reservoir in 1896 before it was filled in as a diver prepares to make underwater repairs. The waterworks was decommissioned in 1911, after a report was issued detailing pollution in the river. (Courtesy of PWD.)

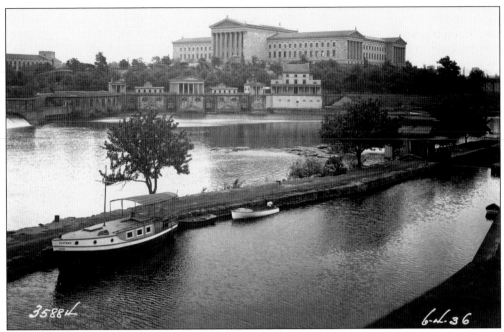

Fairmount Water Works changed dramatically in 1924 when the Philadelphia Museum of Art was built atop the reservoir, seen here in 1936. The mill house served as an aquarium, open from 1919 to 1962, and then as an indoor public swimming pool until 1973. Today it is a national historic landmark and home to the Fairmount Water Works Interpretive Center and a restaurant. (Courtesy of PCA, PhillyHistory.org.)

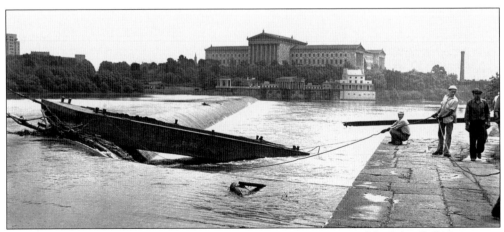

Fairmount Dam was constructed in 1821 with a dual purpose—as part of the Schuylkill Navigation Company's slack water canal system and also to supply waterpower to the waterworks. In this 1946 photograph, men standing on the canal towpath work to remove a wayward canal barge. (Courtesy of Philadelphia Newspapers Incorporated.)

To protect their water supply and prevent pollution from industrial development, early Philadelphia officials began purchasing land along the Schuylkill River. This later led to the creation of Fairmount Park. The first property purchased was Lemon Hill, in 1844, the estate of financier Robert Morris. This c. 1875 image depicts the south and west elevations of Lemon Hill. A sign for ice cream hangs from the second-floor balcony. (Courtesy of LCP, photograph by Frederick Gutekunst.)

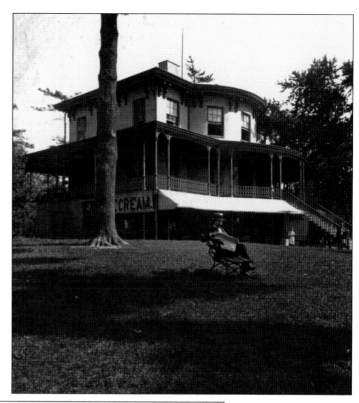

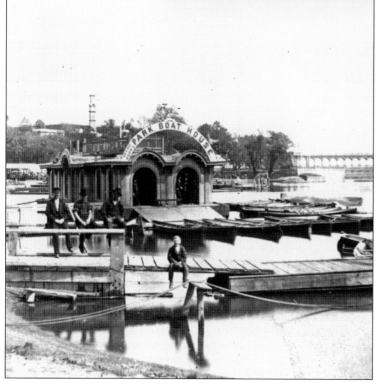

The 1822 construction of Fairmount Dam created a navigable waterway just above the dam that was used for sculling and boat races. Permanent boathouses were built to the north of Fairmount Water Works' gardens beginning in 1860. This 1876 picture shows one of the early boathouses. (Courtesy of LCP, photograph by Robert Newell.)

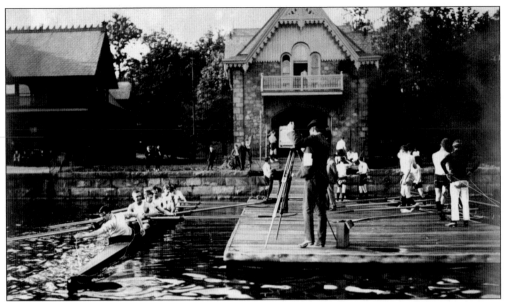

With the establishment of Fairmount Park Commission in 1867, park rules governed development of Boathouse Row. City leaders required private clubs to demolish existing boathouses and rebuild in Victorian Gothic style. This 1904 photograph shows the University of Pennsylvania crew team preparing for a meet near the college boathouse. (Courtesy of University of Pennsylvania, photograph by Pierce and Jones.)

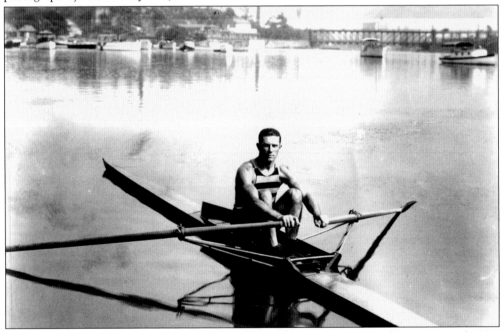

Oarsman John B. Kelly famously won 126 consecutive races in single sculls in 1919 and 1920, when this photograph was taken, and earned three Olympic gold medals. He was the father of the late Grace Kelly, Academy Award–winning actress and Princess Grace of Monaco, as well as John B. Kelly Jr., also an accomplished rower. A statue of Kelly now sits along Boathouse Row on Kelly Drive, named in his honor. (Courtesy of University of Pennsylvania.)

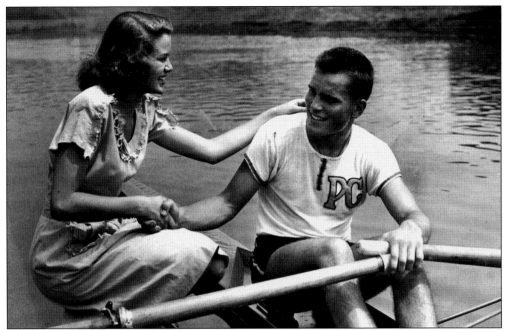

Grace Kelly grew up in East Falls and began her acting career at the amateur theater, Old Academy on Indian Queen Lane, which is still in operation. Here she congratulates her brother John B. Kelly Jr. in 1944, after he won the singles sculling championship. (Courtesy of UA.)

DELIGHTFULLY ROMANTIC SCHUYLKILL EXCURSIONS,

By the swift and comfortable Steamers "Frederick Graff," Capt. Wm. F. Cline, and "Washington," Capt. H. M. Green.

To and from Fairmount, Laurel Hill Cemetery, Falls, and Manayunk, every hour through the day.

Fare to Laurel Hill Cemetery and Falls 10, Columbia Bridge $6\frac{1}{4}$, and Manayunk $12\frac{1}{2}$ cents.

Upon this Excursion you have a great variety of handsome and interesting scenery, a part of which is seven splendid bridges crossing the Schuylkill, and one the beautiful Wissahickon; four railroads; the Inclined Plane; two extensive Water-works; one canal, with its numerous boats, &c.; trains of over 100 loaded cars, attached to a single engine, constantly crossing the river upon the Reading Railroad Bridge.

Steamships once provided transportation along the Schuylkill River. Beginning in 1840, the steamboats *Washington, Mount Vernon,* and *Frederick Graff* brought visitors and funeral-goers hourly from Fairmount Water Works to Laurel Hill Cemetery and back. This advertisement informs visitors that they can travel from Fairmount Water Works to the Columbia Bridge, Laurel Hill Cemetery and East Falls, and Manayunk. (Courtesy of PWD.)

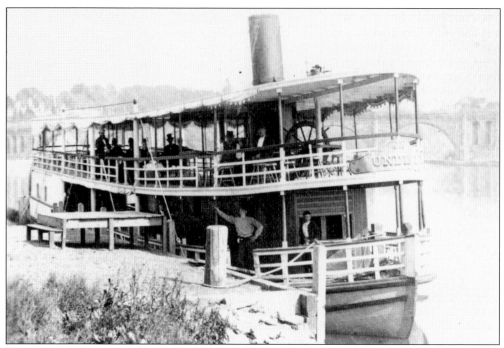

This undated stereograph by James Cremer shows steamboat No. 685, *Undine*, a typical passenger boat that once was a common sight along the river. In 1872, Cremer was the largest publisher of stereo views in Philadelphia. (Courtesy of PWD, from the Raymond Holstein collection.)

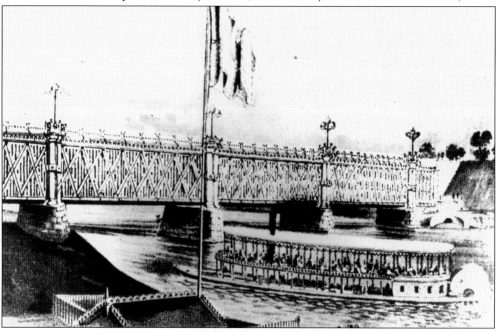

Steamboats also carried visitors to the Philadelphia Zoo and the city's 1876 centennial celebration. This 1876 print shows people on the zoo's wharf, awaiting the steamboat *Undine*, which arrived every 15 minutes. The Girard Avenue Bridge crossed the river near the zoo's entrance and opened in 1874, three days after the zoo's opening day. (Courtesy of Philadelphia Zoo.)

The Philadelphia Zoo, America's first zoo, opened its gates on July 1, 1874. It was built on land owned by John Penn, William Penn's grandson, and his neoclassical home, the Solitude, still stands. This opening day photograph shows the Frank Furness–designed Victorian gates and gatehouse, which continue to greet visitors today. More than 3,000 people showed up for the zoo's opening. (Courtesy of Philadelphia Zoo.)

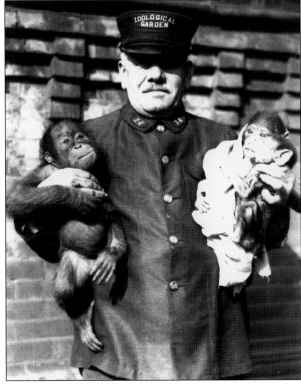

Taken in 1929, this photograph shows zookeeper Jim McCrossen on his 63rd birthday holding, from left to right, orangutan Orphan Annie, a baby chimpanzee, and a papio baboon named Hoover. (Courtesy of Philadelphia Zoo.)

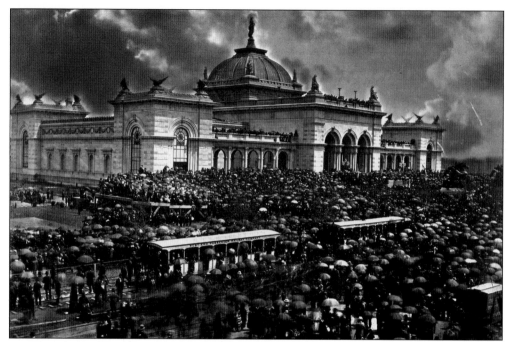

In 1876, Philadelphia hosted the Centennial Exhibition celebrating 100 years of American culture and industry. It opened on May 10, 1876, covering 236 acres of Fairmount Park. In this opening day photograph, crowds gather before Memorial Hall, one of the few centennial buildings still extant. Pres. Ulysses S. Grant and Emperor Pedro II of Brazil were among the speakers. (Courtesy of FLP Print and Picture Collection.)

Nearly 200 buildings were erected for the Centennial Exhibition, including 24 representing different states. Seen here are state buildings of, from left to right, New York, Massachusetts, Connecticut, New Hampshire, and Michigan. The low building in the center is a comfort station. The exhibition closed on November 10, 1876, having hosted more than eight million visitors. Most of the structures were disassembled, and the exhibits were removed. (Courtesy of FLP Print and Picture Collection.)

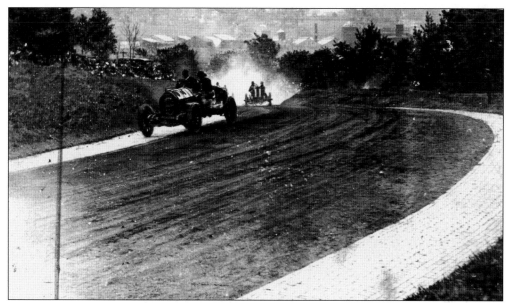

Fairmount Park is one of the oldest and largest municipally owned park systems in the country, encompassing 9,200 acres. The park evolved primarily through the absorption of old estates that had been built along the river by wealthy people seeking to escape the heat in summer. It was designed to provide access to healthy air and water and to foster calming experiences. However, the early 1900s brought automobiles into the park, and soon automobile racing became a popular activity on Chamounix Speedway. (Courtesy of UA.)

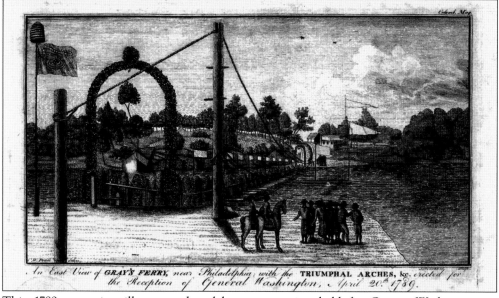

This 1789 engraving illustrates the elaborate reception held for George Washington in Philadelphia as he journeyed from Mount Vernon to New York for the first inauguration. The April 20, 1789, reception took place at Gray's Ferry. The illustration shows the Gray's Ferry Bridge, which was then a floating bridge, decorated with laurels and two 20-foot-high triumphal arches that Washington passed under. Early bridges were often wooden pontoon bridges. (Courtesy of Library of Congress, engraving by Charles Wilson Peale.)

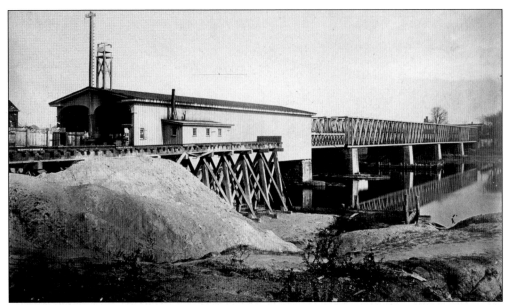

Nearly 100 years later, in 1876, this photograph was taken of the Gray's Ferry Bridge, which replaced the pontoon bridge that George Washington crossed. The railroad drawbridge was constructed in the 1830s. (Courtesy of FLP Print and Picture Collection.)

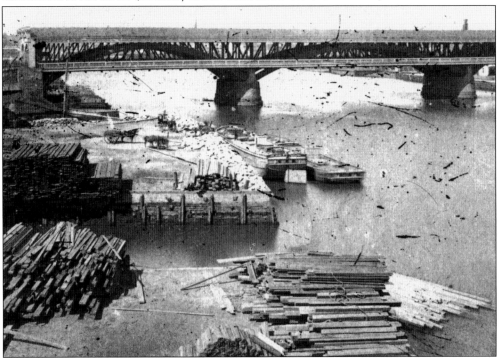

Deemed by some as America's first covered bridge, the 1805 Permanent Bridge crossed the Schuylkill River at what is now Market Street (originally High Street). Since it replaced a pontoon bridge, it was named the Permanent Bridge and covered to protect the wood surface. It was enlarged in 1850 to allow for railroad transportation. This c. 1870 photograph shows the bridge before it was destroyed by fire in 1875. (Courtesy of LCP.)

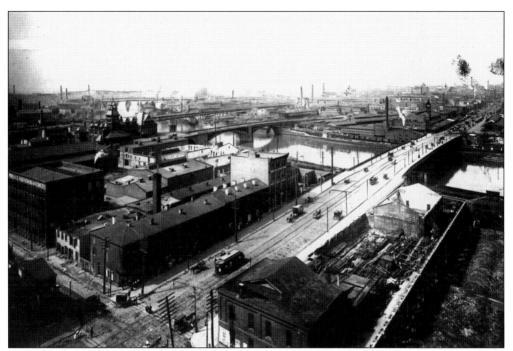

In this 1900 aerial view of a later Market Street Bridge, trolley cars, horse-drawn carriages, and carts are visible. The Chestnut Street Bridge, Walnut Street Bridge, and South Street Bridge can also be seen. These were the principal bridges connecting Center City to West Philadelphia. (Courtesy of FLP Print and Picture Collection.)

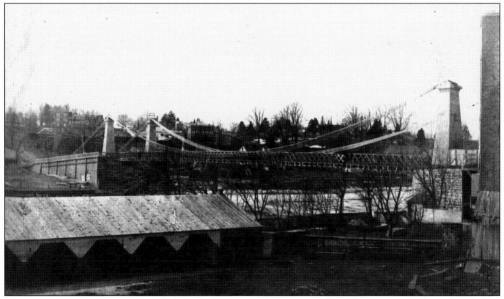

The first Spring Garden Street Bridge was a wooden covered bridge known as Wernwag's Bridge. When it was built in 1813, it was considered the longest arch bridge in the world, spanning 340 feet, and its designer, Louis Wernwag, achieved international fame for it. Destroyed by fire in 1842, it was replaced by the Wire Bridge, shown above, the first cable suspension bridge for vehicles in America. (Courtesy of LCP.)

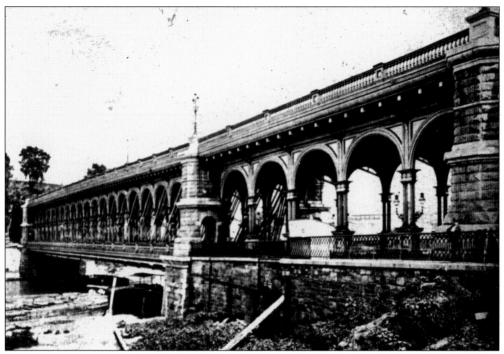

The Wire Bridge stood until 1875, when it was replaced by the Spring Garden Street Bridge, a double-deck truss bridge, with the upper deck connecting to Spring Garden Street and the lower deck to Callowhill Street, where it was called the Callowhill Street Bridge. This stereo view of the lower deck was taken shortly after the bridge opened. (Courtesy of SCA.)

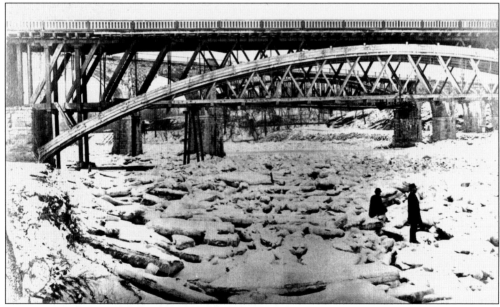

This photograph from 1870 shows the old Girard Avenue Bridge with two men standing beneath it during an ice jam. In the background, a Pennsylvania Railroad bridge can be seen. The Girard Avenue Bridge was torn down in 1873 and replaced by a newer structure that opened in July 1874, three days after the Philadelphia Zoo's opening day. (Courtesy of PCA.)

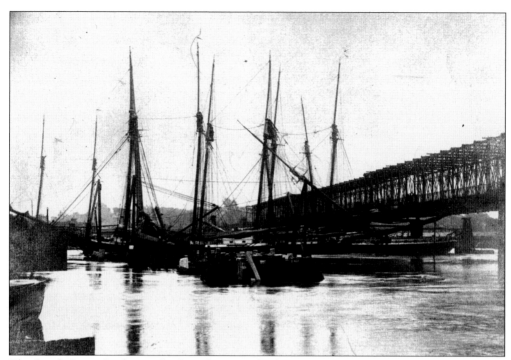

The South Street Bridge was built in the 1870s (replacing an earlier bridge) as a drawbridge that allowed tall ships to pass through. This May 1894 image shows boats jammed up against the bridge, following a spring freshet. (Courtesy of PCA.)

In the late 19th and early 20th centuries, industrial pollution became a greater problem along the Schuylkill River. Sewage was dumped untreated into the water, and textile mills, ironworks, paper mills, and refineries poured waste indiscriminately into the river. Slaughterhouses such as this one were major polluters. Thousands of animals were slaughtered each week, and all unwanted by-products were washed directly into the river and canal. (Courtesy of PWD.)

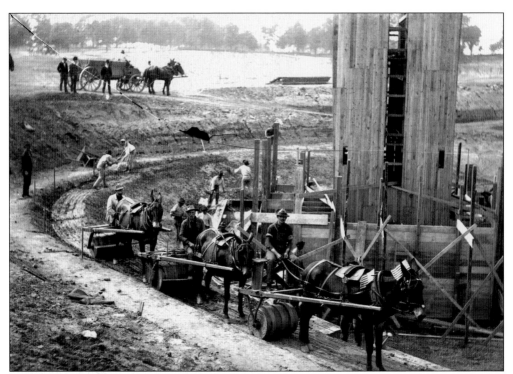

Toward the end of the 1800s, several large outbreaks of typhoid fever—a waterborne disease—led to public demand for water filtration. The Belmont Pumping Station, originally built in 1864 to supply water to West Philadelphia, was used instead to pump water to the Belmont Filter Plant, shown here under construction in 1903. A slow sand filtration system flushed river water through underground beds of sand. (Courtesy of PWD.)

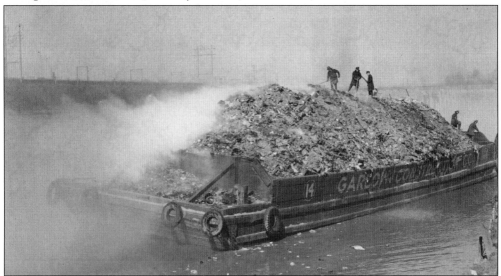

Although drinking water was being filtered, pollution continued unchecked. For decades, the area below Fairmount Dam served as a municipal dump. This photograph, taken in 1949, shows a rubbish barge that caught fire on the river, near the Spring Garden Street Bridge. (Courtesy of UA.)

It was not until the 1950s that sewers were constructed so that sewage and industrial waste could be treated before being dumped into the river. Workers toiled underground to carve out the tunnels where sewer pipes were laid. (Courtesy of PWD.)

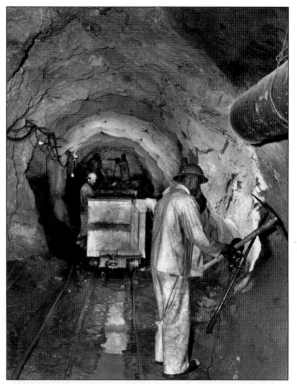

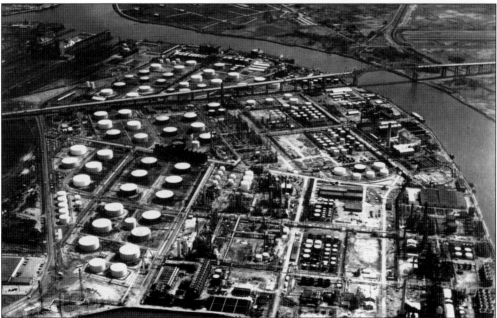

The South Philadelphia refinery, now owned by Sunoco, is the oldest continuously operating petroleum facility in the world. Refineries along the lower Schuylkill River were first built in the 1860s to refine crude oil from upstate Pennsylvania. Today Sunoco's Philadelphia refinery can process 330,000 barrels a day of crude oils into fuels that are used throughout the Northeast. (Courtesy of PWD.)

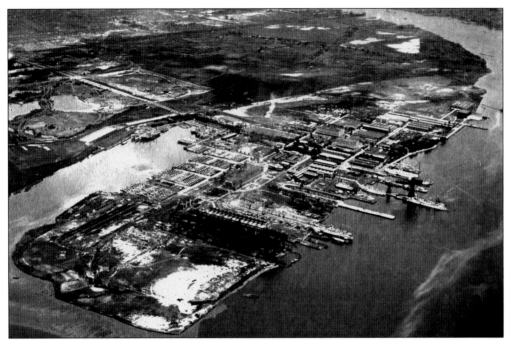

The U.S. Philadelphia Navy Yard was established in 1801 along the Delaware River to build ships for the U.S. Navy. In 1876, it moved to League Island, shown above, located at the confluence of the Delaware and Schuylkill Rivers. Numerous warships and submarines were built there in its 120-year history by a workforce that grew from 300 in 1876 to 58,000 during World War II. It closed in 1996. (Courtesy of PCA.)

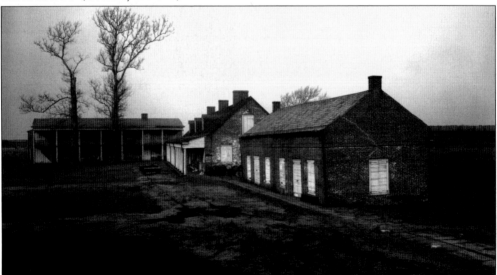

Also located on the Delaware River, near the mouth of the Schuylkill, Fort Mifflin was built in 1771 by the British and was the site of an important battle during the Revolutionary War. It was reconstructed as a coastal defense in 1798 and remained an active military post through the Korean War, serving as a Confederate prison during the Civil War and munitions depot during World Wars I and II. It is now a national historic site. Seen here in 1929 are, from left to right, the storehouse, soldiers' barracks, and officers' quarters. (Courtesy of PCA.)

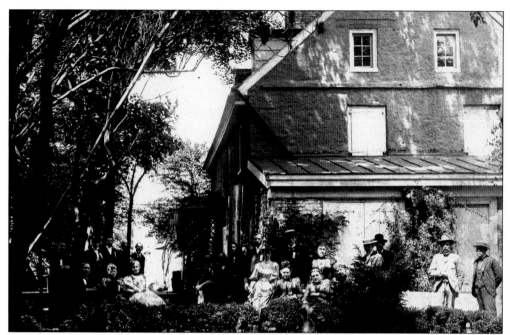

Many historic sites are situated along the lower Schuylkill including Bartram's Garden, home of America's first botanist, John Bartram. A Quaker farmer, Bartram was so inspired by a daisy he found that he and his son, William, spent their lives studying and collecting plants. His home dates to 1731. The photograph shows an 1893 family reunion. (Courtesy of John Bartram Association, Bartram's Garden, photograph by Frederick Gutenkunst Company.)

Industrialist Andrew Eastwick purchased the Bartram property in 1850, preserving it from the industrial sprawl that was then engulfing the lower Schuylkill River. This c. 1875 photograph is thought to be of Eastwick, standing beneath an old Florida cypress. (Courtesy of John Bartram Association, Bartram's Garden, photograph by John Moran.)

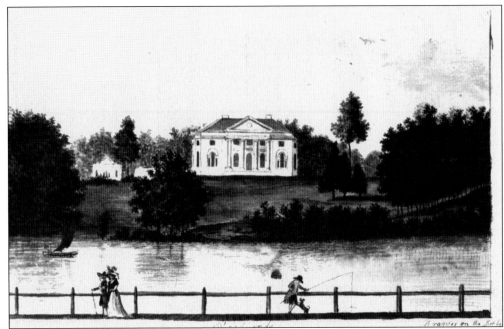

The Woodlands is a national historic landmark in West Philadelphia. It includes the Georgian villa built by William Hamilton in 1768 and expanded in 1792, the year J. P. Malcolm painted this watercolor. Hamilton helped propagate one of the largest collections of plants on the continent, and his estate grew to 600 acres by 1813. The Woodlands Cemetery Company purchased the last 100 acres in 1840 to preserve the land and buildings. (Courtesy of the Woodlands.)

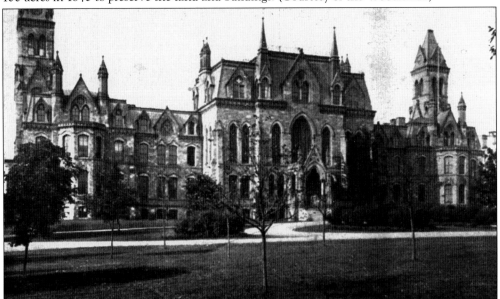

The University of Pennsylvania, also known as Penn, is recognized as America's first university. It dates back to 1749, with Benjamin Franklin among the founders of the early Academy and Charity Schools from which it later emerged. The campus moved to West Philadelphia along the river in 1872. College Hall, pictured here, was one of the original buildings on that site. (Courtesy of PCA.)

Penn's Franklin Field is the oldest collegiate football field still in use in the country. Home to the Penn Relays track-and-field meet since 1895, the stadium also hosted the 1960 NFL championship game when the Philadelphia Eagles defeated the Green Bay Packers 17-13. Here crowds gather in the early 20th century for a football game. (Courtesy of University of Pennsylvania.)

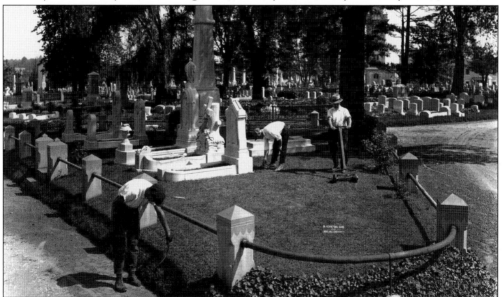

In 1835, Quaker John Jay Smith saw the need for a nonsectarian burial place that would provide a scenic sanctuary for visitors. He and a group of proprietors purchased the 32-acre Laurel Hill estate in 1836, in large part because of its proximity to the river. Laurel Hill Cemetery soon became a popular spot for picnicking and sightseeing, boasting nearly 30,000 visitors from April to December 1848. (Courtesy of Laurel Hill Cemetery.)

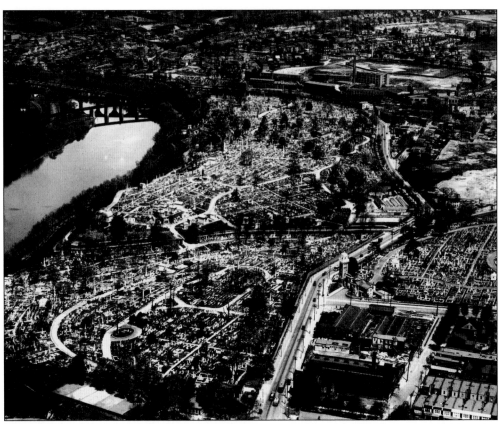

This 1940s aerial photograph shows the greatly expanded Laurel Hill Cemetery, which today totals 78 acres. Designated a national historic landmark in 1998, it serves as the final resting place for 38 Civil War–era generals, six *Titanic* passengers, and many of Philadelphia's leading industrial magnates. (Courtesy of Laurel Hill Cemetery.)

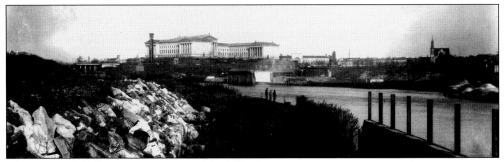

The Philadelphia Museum of Art was originally founded in Memorial Hall as part of the 1876 Centennial Exhibition. By 1907, larger facilities were needed, and the site of the former Fairmount Water Works reservoir was chosen. The first section opened in 1928, designed to echo neoclassical waterworks buildings. In this 1940s photograph, city officials stand across from the museum, surveying the future site of the Schuylkill Expressway. (Courtesy of PCA.)

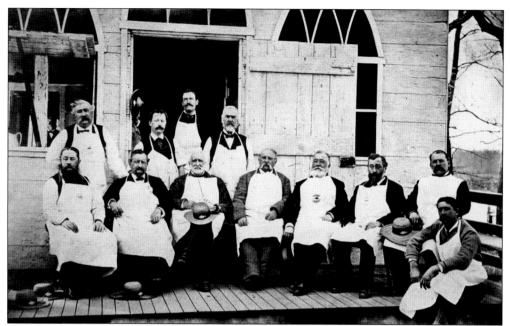

The State in the Schuylkill Fishing Company was founded in 1732 by 27 Quakers who came to America with William Penn. A meetinghouse, the "Castle," was built on the banks of the Schuylkill River near Fairmount, where club members combined their hunting and fishing catches and dined monthly. The elite club maintained its rules for centuries, with apprentices donning white aprons and straw hats to cook and serve meals. (Courtesy of FLP Print and Picture Collection.)

When construction of Fairmount Dam in 1822 negatively impacted fishing, the Castle was dismantled and moved downriver to Rambo's Rock. Later pollution forced the club to move to the Delaware River. Considered the oldest continuously existing social club in the world, it purportedly served 10 presidents, including George Washington. Most visitors probably tasted the club's Fish House Punch, a concoction of brandy, lemon juice, and tea. (Courtesy of LCP.)

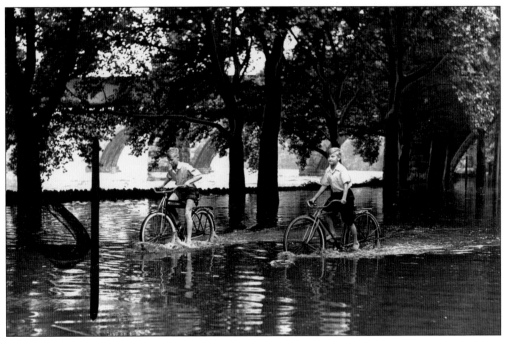

The *Philadelphia Inquirer*'s caption for this August 9, 1942, photograph reads, "Two boy cyclists are seen splashing through water covering the East River Drive in the East Falls section of Fairmount Park after the Schuylkill overflowed its banks yesterday." The boys, Leo Posatko and Eugene Rogalski, were photographed at Ferry Road, a few blocks north of Nicetown Lane. (Courtesy of Philadelphia Newspapers Incorporated.)

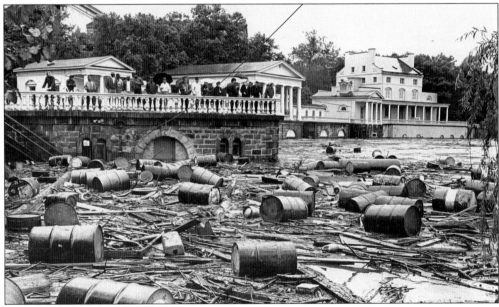

Flooding has long been a problem associated with the river. This 1972 photograph shows debris floating in the water in front of the Fairmount Water Works following the flood that resulted when Hurricane Agnes wreaked havoc across the region. (Courtesy of Philadelphia Newspapers Incorporated.)

Two

EAST FALLS, MANAYUNK, AND UPPER MERION

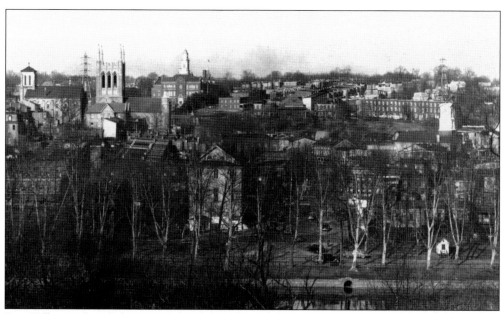

East Falls was founded over 300 years ago alongside a falls in the Schuylkill River where fish were abundant and early fisheries flourished. In 1822, Fairmount Dam was built three miles downriver, submerging the falls. The town continued to prosper as an industrial center. In this 1946 photograph, taken from a trolley, St. Bridget's Roman Catholic Church (built in 1855) is a prominent feature. (Courtesy of EFHS.)

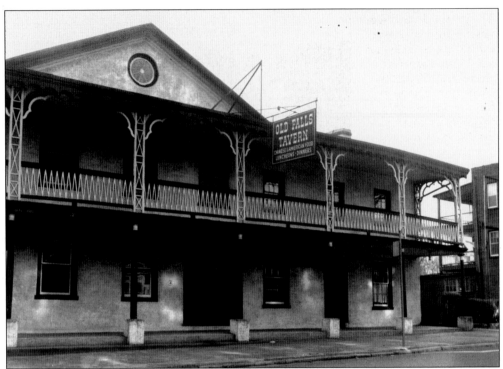

Originally dating to the 18th century, the Old Falls Tavern was located along the river, where catfish were plentiful. The original owner, a Mrs. Robert Watkins, is said to have served a popular delicacy of catfish and waffles. Shown here in 1951, the building was demolished in 1971. (Courtesy of UA.)

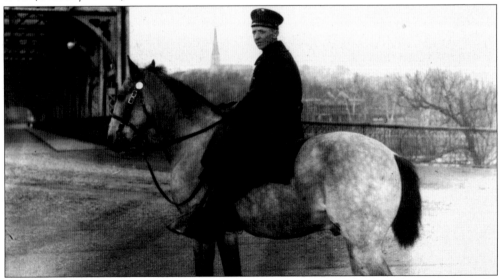

John Lavery, a member of the Fairmount Park Guard, sits on horseback at the entrance to the Falls Bridge. The Fairmount Park Guard patrolled the entire park system from the 1870s until 1972, when the Philadelphia Police Department took over those duties. The bridge, built in 1894–1895 and still in use, was planned as a double-deck bridge, but the upper deck was never constructed. (Courtesy of EFHS.)

The existing Falls Bridge was preceded by several earlier bridges, including a pedestrian structure erected in 1816 that is credited with being the first wire suspension bridge in the country. Several wooden bridges came after, including the covered bridge pictured at right from sometime before 1896. All were washed away in floods. (Courtesy of SCA.)

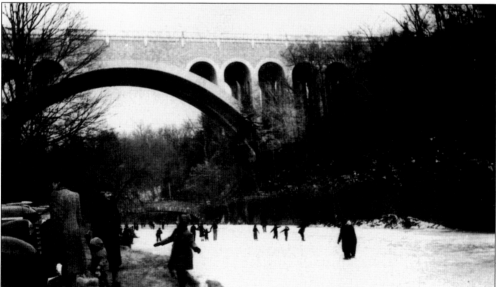

The Wissahickon Creek, which flows into the Schuylkill River near East Falls, has a natural beauty that once attracted famous literary figures including Edgar Allan Poe. It was also a recreational amenity. Here skaters beneath High Bridge enjoy the frozen creek. Today the area is part of Fairmount Park with popular walking and biking trails. (Courtesy of EFHS.)

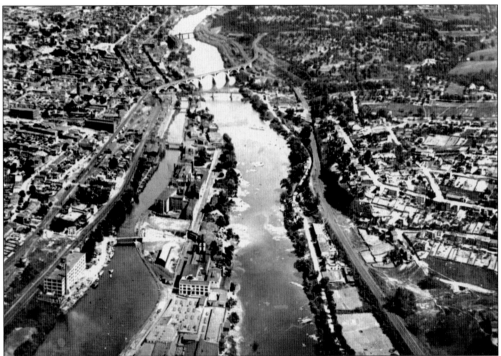

Just above East Falls sits Manayunk, originally called Flat Rock, which developed largely as a result of the Schuylkill Canal. The canal was built to make the river navigable, but dams also provided waterpower for mills. This photograph shows the canal, left, and the river, center, with Venice Island between them. The Manayunk S Bridge, a concrete Pennsylvania Railroad viaduct, is also visible. (Courtesy of MDC.)

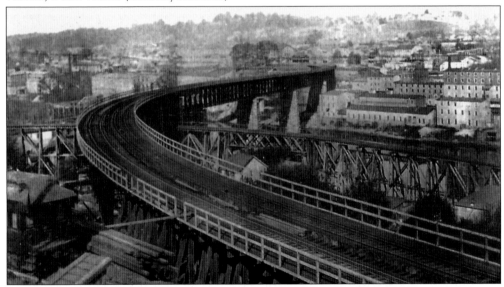

The S Bridge was built in 1883 as part of the Pennsylvania Railroad Schuylkill Valley Division. It consisted of nine spans of Pratt trusses and five of plate girder, along with timber trestle work. In 1917, it was removed and replaced with the concrete arch bridge that is still standing and is a landmark in Manayunk. (Courtesy of FLP Print and Picture Collection.)

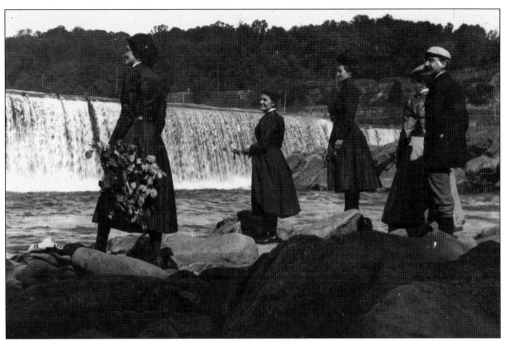

Flat Rock Dam was located at the head of the Manayunk Reach of the canal. This 1900 image by William Harvey Doering depicts his wife, Catherine Rupp Doering, holding dogwood branches. Other figures have been identified only as a Mrs. Lindsey, a Mrs. Schwarts (the photographer's sister), and Al Schwarts. Doering took a series of photographs from this outing and others along the canal, including the one below, in which Al Schwarts, center, and Al Lindsey, left, are cycling along the canal. Today the Manayunk Canal is part of the popular Schuylkill River Trail and is used heavily by area cyclists. (Courtesy of LCP.)

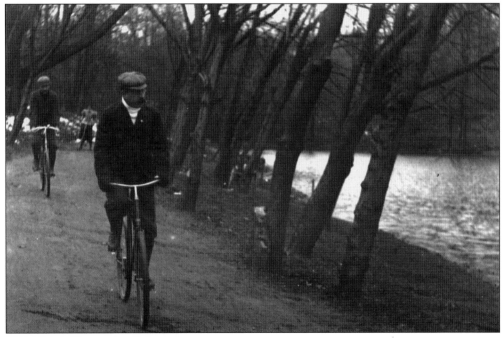

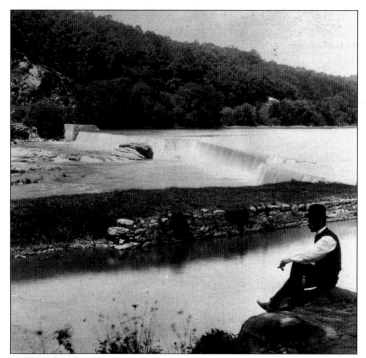

Flat Rock Dam was built in 1819, the year the Manayunk Canal was completed, making a difficult section of the river navigable. Prior to that, the area around Flat Rock (so named for an unusually shaped rock) was navigable only during periods of high water. In 1842, the Philadelphia and Reading Railroad (P&R) was completed, leading to the gradual decline of the Schuylkill Navigation System. This 1897 photograph was taken before the last canal boat came through Manayunk in 1916. (Courtesy of PCA.)

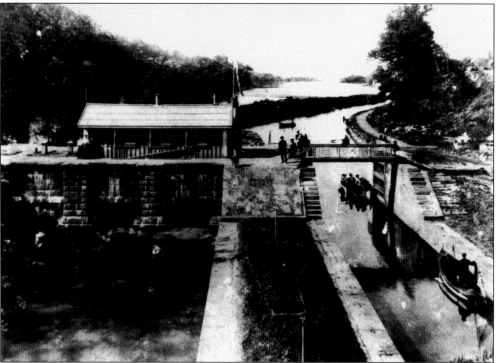

The Manayunk Canal consisted of locks 68, 69, and 70. Beside lock 68, located just below Flat Rock Dam, was the Shawmont Sluice House, which housed machinery that operated the sluice gates. The water level in the canal was regulated by opening and closing the sluice gates. Adequate water was needed to keep the mills running. (Courtesy of MDC.)

Capt. Winfield Scott Guiles served as the lock tender of lock 68 for more than 60 years. His wife was purportedly a Native American of Lenni-Lenape heritage and skilled at healing using herbs and plants. (Courtesy of MDC.)

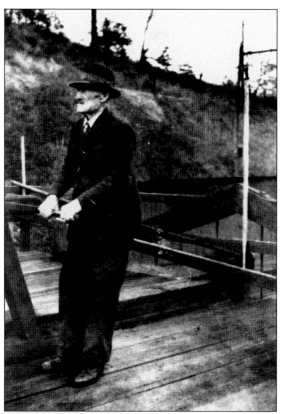

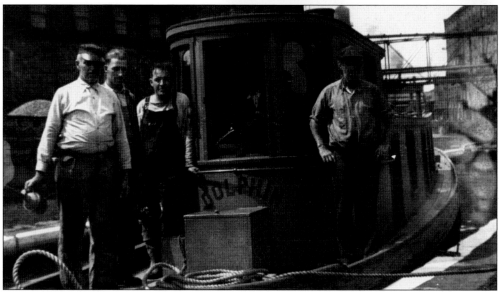

The *Dolphin* was one of several dredge boats that regularly dredged coal silt from the canal. Here it is seen in the Manayunk Canal outlet lock on its final dredging trip in 1937. Pictured are, from left to right, its crew, Vincent Moyer, engineer; Floyd Crowl, spud tender (fireman on the dredge); Jim Hinkel, scow tender; Rubin Waters, pilot; and Billy Bean, deckhand. (Courtesy of SCA.)

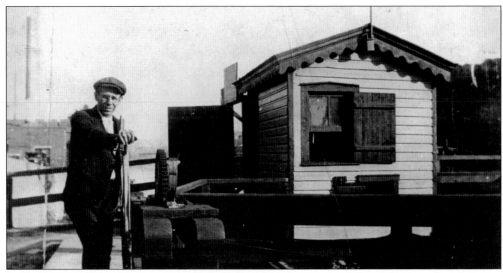

Locks 69 and 70 took boats out of the canal and back into the Schuylkill River by raising or lowering the water level. This photograph shows lock tender John Wright operating the outlet lock. (Courtesy of SCA.)

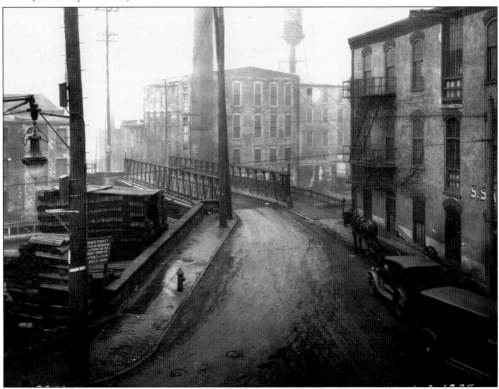

Water- and steam-powered mills were built along both sides of the canal in Manayunk. This undated photograph shows the S. S. Keely and Sons planing mill on the right around 1876. Directly across the canal on the left is the c. 1870 Blankin Mill, a yarn company. The area was once a textile-manufacturing center that produced blankets for the Union army during the Civil War. (Courtesy of PCA.)

Hunting has always been popular in Pennsylvania, and Manayunk natives are no exception. Here a group of men and boys stand before a restaurant where their catch is proudly displayed. (Courtesy of MDC.)

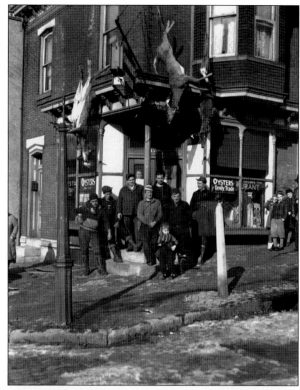

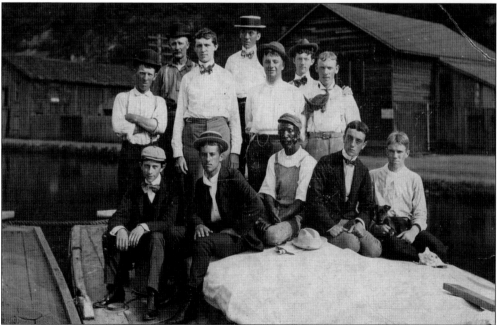

This group photograph is believed to have been taken near Manayunk in the early 1900s. Carpenter John Elwell of Frankford worked with this group of men along the Schuylkill Canal during that period. This photograph was provided by his grandson William Britland. (Courtesy of SCA.)

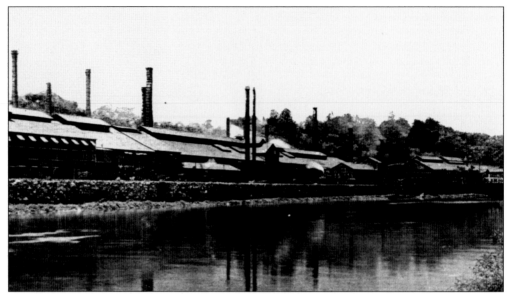

Pencoyd Iron Works was founded in 1852, when brothers Algernon and Percival Roberts recognized that their family farm, Pencoyd (Welsh for "head of the woods"), was well suited for a foundry. It was situated along the river in what is now Lower Merion Township, along the route of the P&R, so raw materials and finished goods could easily be transported. The company soon began producing bridge parts and grew to become a leading bridge producer, constructing hundreds of bridges across North America. In 1900, when Pencoyd Iron Works became the American Bridge Company, the plant employed 1,000 men, many of whom performed difficult and dangerous tasks daily. The plant operated through World War II and then closed. (Courtesy of MDC.)

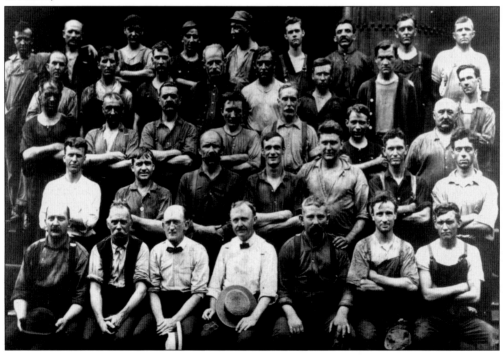

Three

CONSHOHOCKEN TO VALLEY FORGE

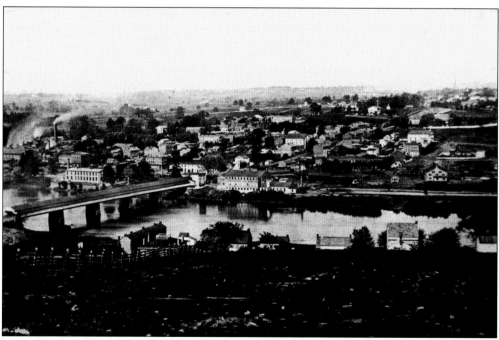

The Matson Ford covered bridge, shown here in 1866, was the first bridge linking Conshohocken and West Conshohocken. Conshohocken was settled in 1712 by John Matson, whose son Peter created a ford by laying rocks across the river. In 1777, the Marquis de Lafayette attempted to lead the Revolutionary army across the Schuylkill River here by forming a bridge of wagons topped by rails. The soldiers were forced to retreat. (Courtesy of CHS.)

In the far right of this 1900 photograph of West Conshohocken is the iron bridge that replaced the covered bridge in 1872. Also visible is the Plymouth Dam on the left. The long building in the center is the Merion Worsted Mills, and the small building just behind it is the West Conshohocken train station. The smokestacks on the far left belonged to the West Conshohocken Stone Quarry. (Courtesy of HSMC.)

In 1921, a new concrete bridge was built to replace the iron bridge shown in the photograph above. The concrete bridge, pictured here shortly after its completion, had a surface of wooden blocks that required a protective coating of creosote. The surface proved to be too slippery in poor weather conditions, and the wooden blocks were later removed. (Courtesy of CHS.)

46

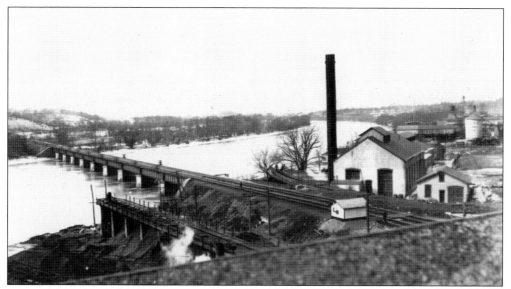

The introduction of the Schuylkill Canal to Conshohocken in 1824 precipitated construction of a number of mills, including an iron rolling mill built by James Wood and his son Alan in 1832. This eventually evolved to become the Alan Wood Steel Company, the largest employer in Montgomery County with 5,000 workers in the 1950s. The railroad bridge pictured carried molten steel to the fabricating plant across the river. (Courtesy of CHS.)

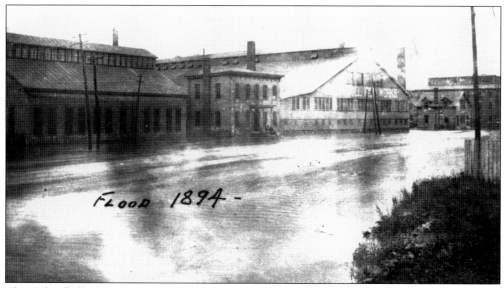

The Schuylkill Iron Works was built in 1857 by Alan Wood and his son Alan Wood Jr. It was situated along the Schuylkill River and the Norristown branch of the Reading Railroad, manufacturing sheet and plate iron. This 1894 photograph shows its location also made it subject to damage by floods. (Courtesy of Jack and Brian Coll.)

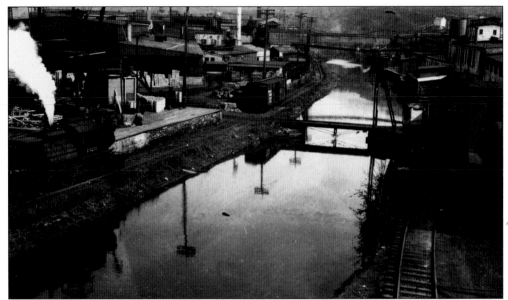

The John Wood Manufacturing Company was founded in 1867 by John Wood, another son of James Wood, who was twice married and fathered 20 children. The John Wood Manufacturing Company was one of Conshohocken's chief manufacturers, specializing in the production of freight cars and steam boilers. (Courtesy of Jack and Brian Coll.)

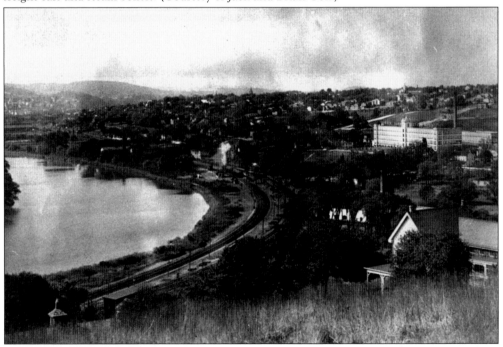

Lee Tire and Rubber Company, right, was another prominent Conshohocken industry. Established in 1910 by J. Elwood Lee, it grew to command a workforce of over 850 and sold tires around the world. Lee was a progressive employer who allowed women to hold managerial positions and fostered open communication. The company closed in 1978, but the building on Hector Street continues to be used as offices. (Courtesy of CHS.)

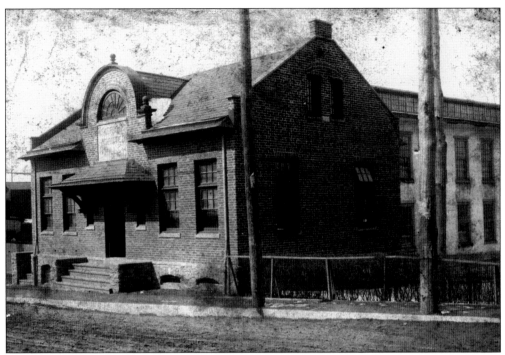

Large textile mills operated all along the lower Schuylkill River, producing, among other things, woolen cloth for the U.S. Army and federal government through World War II. Pictured above is the Merion Worsted Mills office building, sometime before 1910, located just beyond the bridge over the Schuylkill River in West Conshohocken. It was demolished to make room for the Tower Bridge office buildings. (Courtesy of CHS.)

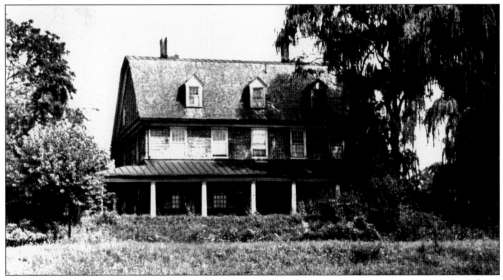

The Peter Legaux Mansion, located in Spring Mill and originally known as Mount Joy, dates back to 1715. Legaux, a French nobleman, hosted George Washington there on July 22, 1787, and established America's first vineyard on the property, which overlooks the Schuylkill River. It is now owned by the Spring Mill Fire Company and is on the National Register of Historic Places. (Courtesy of CHS.)

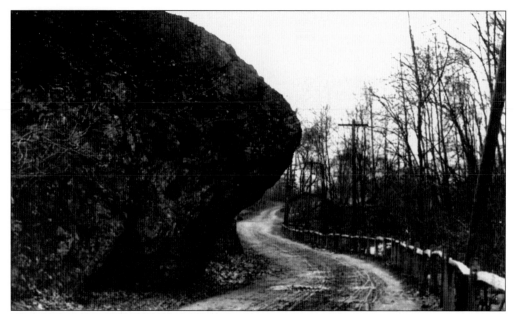

The overhanging rock at Gulph Mills is also on the National Register of Historic Places. From December 13 to 19, 1777, Gulph Mills served as the last prolonged encampment of George Washington and his army before wintering at Valley Forge. The army was in near defeat as it traveled the Gulph Road and passed under this rock on its way to Valley Forge. (Courtesy of CHS.)

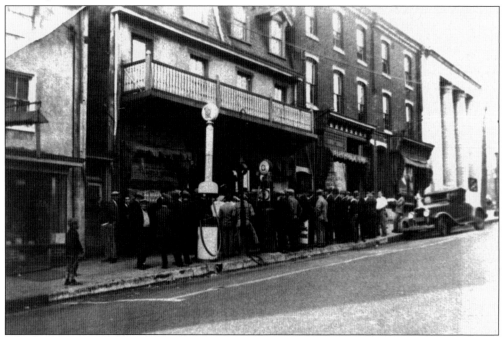

Fayette Street, named for the Marquis de Lafayette, a general who led the Revolutionary army along it, is the main thoroughfare through Conshohocken and was the heart of the downtown. This early-1900s photograph shows people gathered around a storefront, listening to the World Series on the radio. (Courtesy of CHS.)

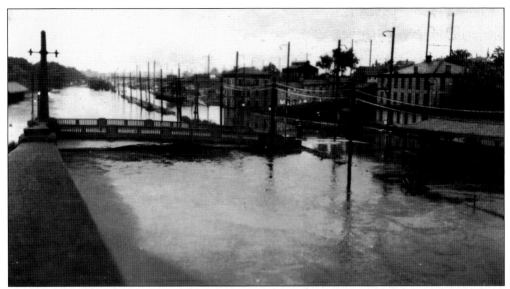

The Schuylkill Canal was once a central feature of Conshohocken. Here, during a flood in 1933, the canal is pictured from the main bridge, looking northwest. The canal has since been filled in. (Courtesy of Jack and Brian Coll.)

Two mules can be seen being led along the canal towpath. This location has changed dramatically since this photograph was taken. It is now the Route 422 east exit ramp at Chemical Road in Plymouth Township. (Courtesy of CHS.)

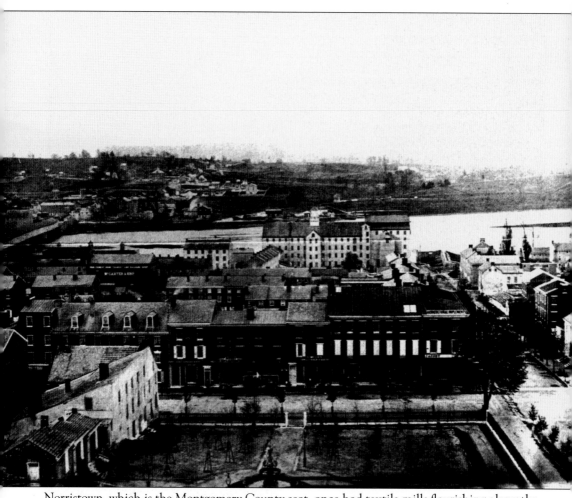

Norristown, which is the Montgomery County seat, once had textile mills flourishing along the river and a downtown that served as a popular shopping center for nearby communities. This picture, taken from the Montgomery County Courthouse, shows the Norristown Public Square in 1858, when it was first built. Visible opposite the square are several shops, including Auge's Hat, Cap, and Clothing Store beside a confectionery and bakery. To the far left is the covered bridge that crossed into Bridgeport. It was destroyed by fire in 1924. (Courtesy of HSMC.)

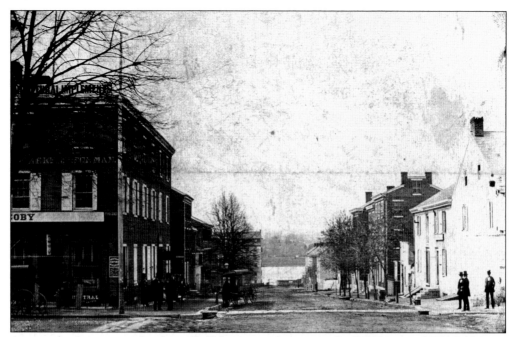

Among the famous people who called Norristown home was Civil War general Winfield Scott Hancock, who was raised in the borough. This photograph shows his father's house, a three-story building on the left, located just beyond the alley on Swede Street, below Main Street. (Courtesy of HSMC.)

Montgomery County–born Winfield Scott Hancock, known for his service as a Union general at the Battle of Gettysburg, was the Democratic nominee for president in 1880. Despite a strong campaign, Hancock was defeated by James Garfield by less than 10,000 votes, in what was the closest popular vote in American history. Hancock is buried in Norristown. (Courtesy of Kurt D. Zwikl.)

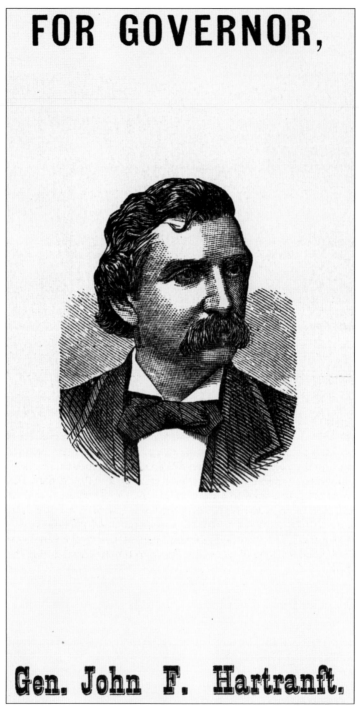

FOR GOVERNOR,

Gen. John F. Hartranft.

Norristown resident John F. Hartranft, a Civil War general, was awarded the Congressional Medal of Honor and twice elected governor of Pennsylvania. Sixteen of the commonwealth's governors were either born in or elected from one of the five counties (Philadelphia, Montgomery, Chester, Berks, and Schuylkill) in the southeastern part of the state that is now designated the Schuylkill River National and State Heritage Area. (Courtesy of Kurt D. Zwikl.)

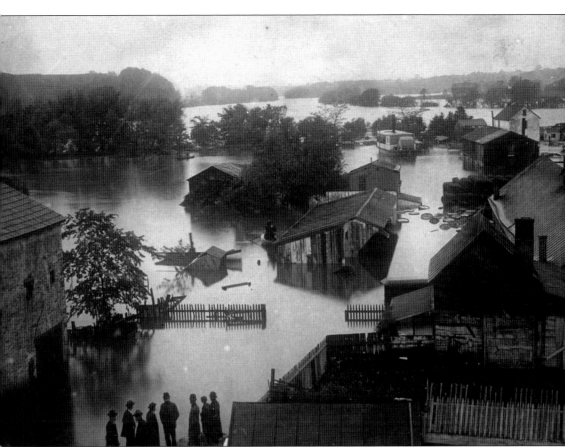

Although it was known as the Norristown Canal, this section of the Schuylkill Navigation System was actually in Bridgeport. During this 1894 flood, several industrial buildings surrounding lock 64 were inundated, including Wright's Flour and Grist Mill, on the left, and the Dager and Company paper mill located at the lock basin. The paddle wheel steamboat in the center operated in the 1890s, taking excursions along the river. Floods like this were catastrophic for the canal, because they damaged dams, locks, boats, and canal structures and shut the canal down for weeks at a time. The associated expense contributed to the canal's eventual demise. This May 21, 1894, flood was one of five major floods to hit the canal during the 19th century. (Courtesy of HSMC.)

At the foot of Haws Avenue, on the banks of the Schuylkill River, the Haws Avenue Boathouse (above) served as a men's boating club from 1914 to 1922. This area was heavily industrialized and later became an eyesore full of dilapidated buildings. In 1955, the town council of the Borough of Norristown leased an 800-foot strip of river frontage from the Pennsylvania Railroad along Haws Avenue and created a recreation area. Old buildings were demolished and replaced with a park with swimming, fishing, and picnicking along the upper 400 feet (below). The remaining land was subleased to the Norristown Boat Club, established that year, with docks for 32 boats, a gas pump, and a refreshment stand. Today this is the site of Riverfront Park. (Courtesy of HSMC.)

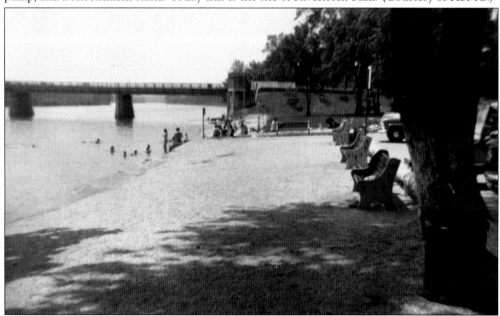

Dam 28 of the Schuylkill Navigation System was known as Catfish Dam, and lock 63 was called Catfish Lock. It was located in Port Kennedy, just upstream from Norristown. In this undated photograph, the railroad tracks that replaced the canal can be seen in the background. (Courtesy of HSMC.)

Washington's Headquarters in Valley Forge was a small two-story stone Georgian-style home with only two rooms on each floor. It is believed to have been originally built by the Potts family as a summer residence. Long after the Revolutionary army's famous encampment at Valley Forge, the home remained a private residence. This photograph, the earliest known of Washington's Headquarters, dates back to about 1861. (Courtesy of Valley Forge National Historical Park.)

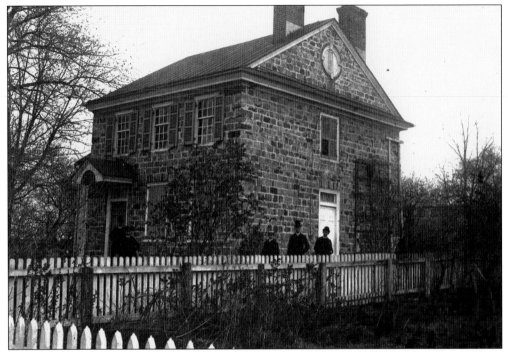

This 1887 picture shows men in top hats visiting the famous Washington's Headquarters in Valley Forge. The home was privately owned until a committee formed to purchase it in 1878. Until that time, little had been done to preserve either that building or the adjoining 1777–1778 encampment site of George Washington's army. (Courtesy of HSMC.)

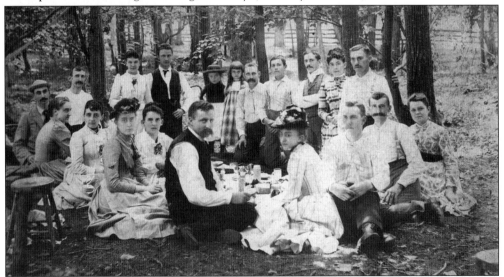

Today Valley Forge National Historical Park welcomes over one million visitors annually. On July 4, 1890, when this photograph of the Cope family was taken near an old fort at Valley Forge, the property was not a public park, although a movement to preserve it had gained momentum. In 1893, the state legislature appropriated $25,000 to purchase 250 acres and establish the park that today totals 3,466 acres. The National Park Service gained ownership of the park during the bicentennial celebration in 1976. (Courtesy of HSMC.)

Four

Phoenixville and Mont Clare

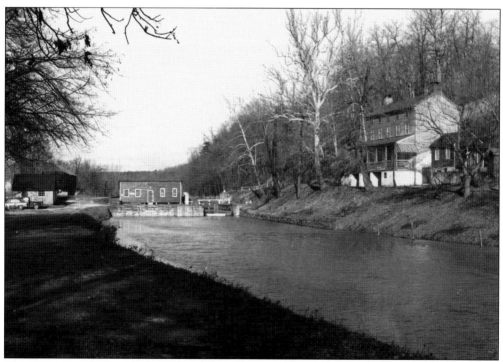

The three-story lock 60 lock tender's house in Mont Clare, pictured here in 1958, dates to the 1830s. This section of canal was hand dug by immigrant workers in 1820. The last lock tender, Emmanuel Schaeffer, remained after the state came into possession of the canal in 1949. The home is now a visitors center for the Schuylkill Canal Association. The carpenter's shop, center, was used by canal boat maintenance crews. (Courtesy of SCA.)

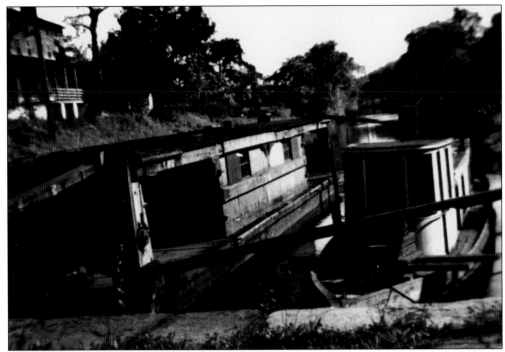

The canal needed to be dredged regularly to remove coal silt and keep it navigable. This photograph shows dredge No. 2 on the left next to the *Dolphin*, which pulled it, at lock 60, shortly before both were dismantled in 1940. Today the restored lock 60 is the only working lock remaining on the canal and one of only 2 watered canals of the system's original 23. (Courtesy of SCA.)

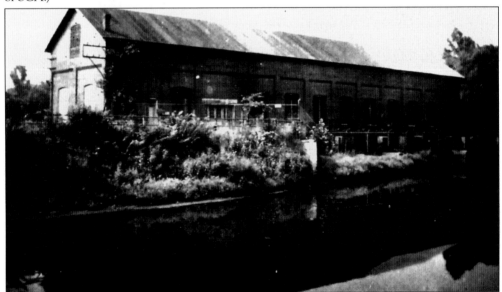

As the canal became less useful as a mode of transportation, its dams were used for waterpower. At Black Rock Dam, just above lock 60, this power plant was built in 1902 by the Reading Traction Company and generated enough electricity to run a trolley from Reading to Norristown. (Courtesy of SCA.)

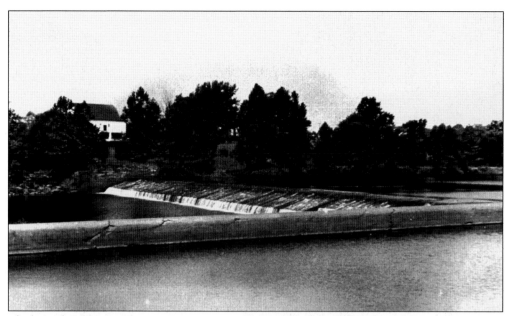

Black Rock Dam, seen here in 1940, is located along the Schuylkill Canal in Mont Clare. The canal was a 108-mile-long navigation system that consisted of a chain of 32 dams, each creating a dam pool 2 or 2 miles in length. Every dam and falls dropped the river to a lower level, and 23 canals provided passage for boats around the changes in water levels. (Courtesy of SCA.)

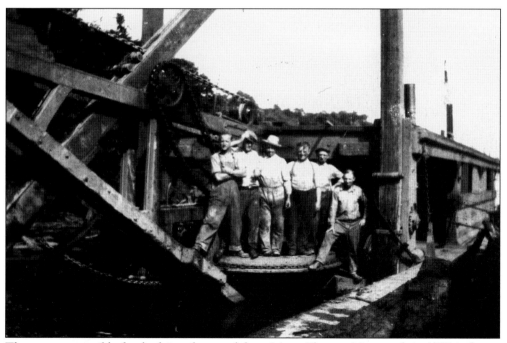

The crew responsible for dredging the canal from Mont Clare to Manayunk in 1929 is shown here at lock 60, where the *Dolphin* was ported. The people are identified as, from left to right, Earl Schaffer, Floyd Croll, Vince Moyer, David Schaffer (foreman), Charles Hummel, and William Bean. (Courtesy of HSPA.)

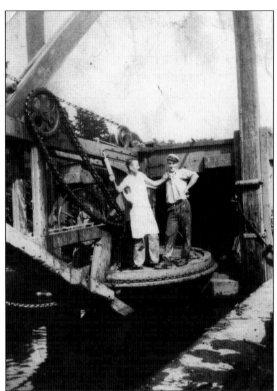

Two crew members, including the cook, clown around for this photograph, which clearly illustrates the massive gears that operated the dredge. Dredging coal culm from the canal was a full-time job in the early 20th century, with crews working their way up and down this part of the canal throughout the week and taking a train home for the weekend. (Courtesy of HSPA.)

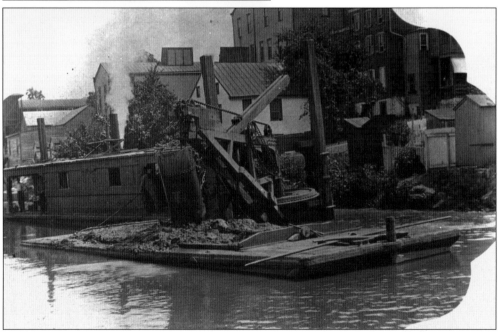

This photograph shows the Schuylkill Navigation Company's dredge No. 2 at work at the stop gate of the Vincent Canal in Spring City. The dredge scooped silt and debris from the bottom of the canal and poured it onto a flatboat. Coal that was dredged from the river was reclaimed and marketed. (Courtesy of SCA.)

In 1919, Black Rock Bridge, just above Phoenixville, included a mule walk so mules could pull boats across the river where the canal switched from the Chester County side to Montgomery County. Here a close-up of the mule walk is shown. Earlier a ferry operated at this location. The covered bridge is long gone and is now the site of the Route 113 bridge. (Courtesy of National Canal Museum Archives.)

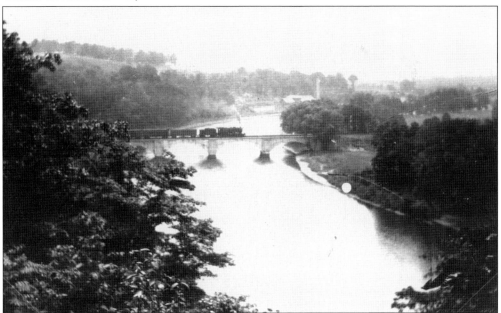

This P&R bridge is located about a half mile southwest of Black Rock Dam. The train in this photograph just passed through the 1,931-foot-long Black Rock Tunnel, which was cut through Black Rock and ends at the edge of the river. Constructed from 1835 to 1837, and later expanded, it was the second railroad tunnel built in America. (Courtesy of HSPA.)

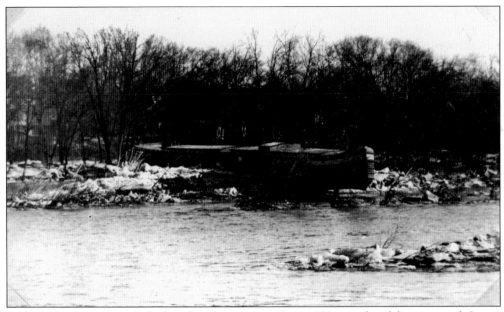

In 1918, this barge was docked at the Montgomery County Home after delivering coal. It was pulled loose by a flood and carried over Black Rock Dam and under two bridges until, as shown here, it beached on a small island below Mont Clare. It sat for a year until another flood carried it to Oaks where it sank. (Courtesy of HSPA.)

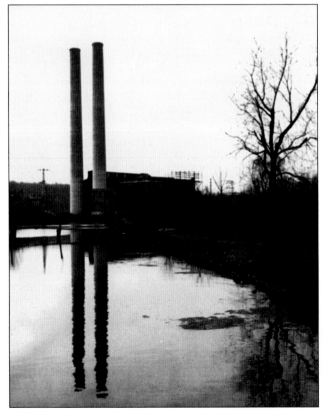

This view of the Vincent Canal below Spring City shows the Philadelphia Electric Company (PECO) power station at Cromby, which had its first generator installed in 1918 and was shut down in 1929. It was torn down in 1951 to make way for the existing power plant, which has been in operation for more than 50 years. (Courtesy of SCA, photograph by Harold Amster.)

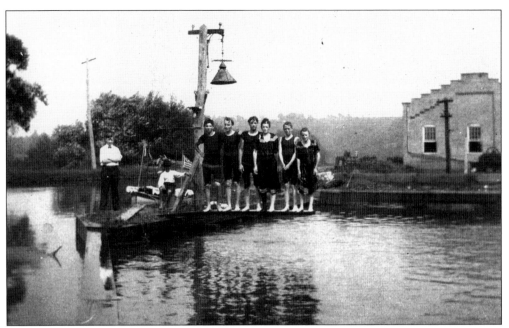

Despite the fact that the canal was polluted with coal silt, it was a popular swimming spot after it was no longer used for coal transportation. This *c.* 1920s photograph shows swimmers at the canal at Cromby, just north of lock 59. (Courtesy of HSPA.)

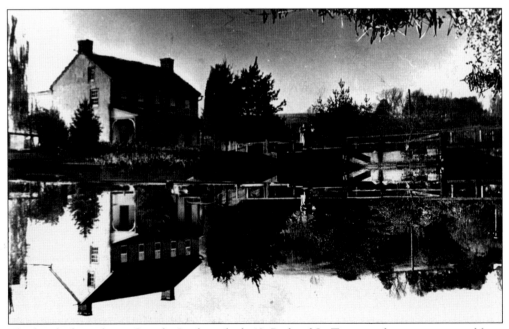

The last lock tender at Cromby Lock, or lock 49, Richard L. Turner, is being interviewed by a local newspaper reporter in this 1947 photograph, which also shows the upper gates of the lock and the lock tender's house. (Courtesy of SCA.)

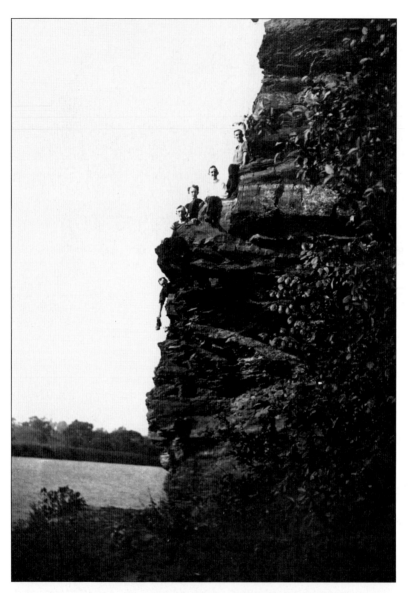

Hills of a hard, metamorphic slate edge the river near Phoenixville, causing the river to take a sharp bend around them. In this early-1900s photograph, climbers stand on one of those hills identified as Indian Rock between Cromby and Black Rock Tunnel. (Courtesy of HSPA.)

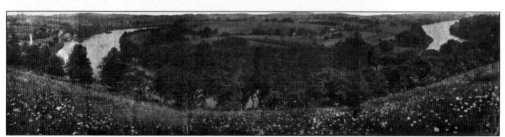

The sharp bend in the river can be clearly seen in this c. 1919 photograph, taken by *Philadelphia Inquirer* photographer Joe Sperry from Reservoir Park in Phoenixville. To the left is the Schuylkill Canal lock gate at Cromby and the pumping plant that brings water to the reservoir. (Courtesy of HSPA.)

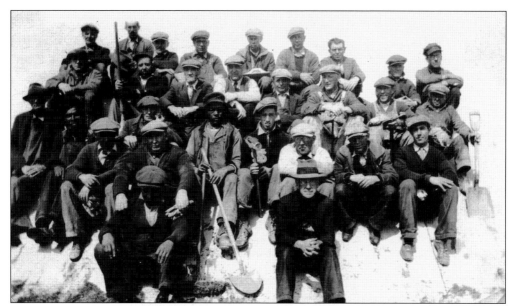

The Phoenixville Reservoir was constructed in the 1930s as part of the Works Progress Administration. Here workers, some with their shovels in hand, take a rest along the banks of the unfinished reservoir. (Courtesy of HSPA.)

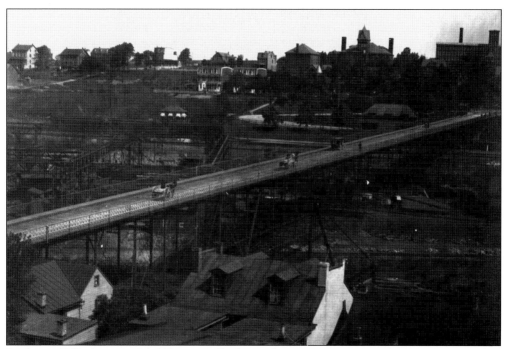

In this *c.* 1850 photograph of Phoenixville, horse-drawn carriages cross the Gay Street Bridge, which had iron railings and metal underpinnings. The P&R station, to the left of the bridge, and Phoenix Iron Works above it can be seen. The house roofs on the north side of Phoenixville are in the foreground. (Courtesy of HSPA.)

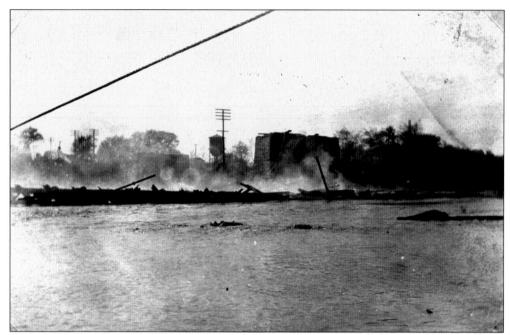

The remains of the wooden, covered Mont Clare Bridge are seen smoldering after a fire in 1913. Built in the mid-19th century, the bridge carried horse-drawn vehicles and later cars over the Schuylkill River. In Colonial days, this was the site of Gordon's Ford where a Revolutionary War skirmish took place, with the British on the Phoenixville side of the river and the Continental army in Mont Clare. (Courtesy of HSPA.)

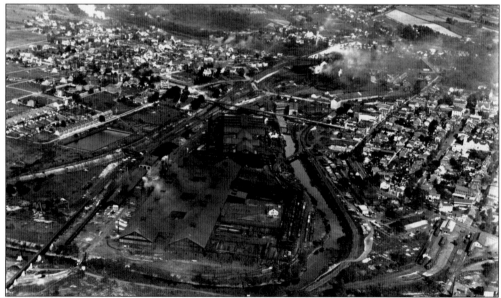

During the Industrial Revolution, Phoenixville was a thriving manufacturing center, occupied primarily by Phoenix Iron Works. Originating as a small nail factory in 1812, the ironworks grew to become a major manufacturer by the mid-1800s. This 1929 aerial photograph shows how the ironworks once occupied a large portion of Phoenixville. (Courtesy of Hagley Museum and Library.)

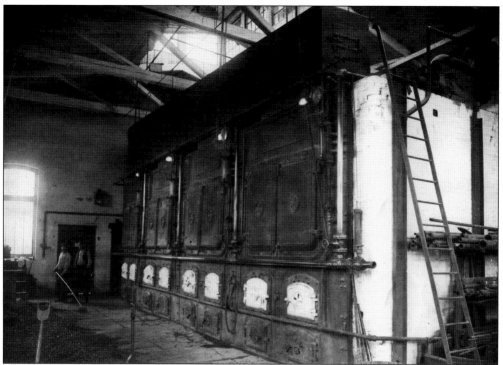

During the Civil War, Phoenix Iron Works was a major producer of cannons for the Union army. But the company is perhaps best known for creating the Phoenix column, patented in 1862, which helped facilitate the construction of tall buildings, bridges, viaducts, and elevated rail lines. Here two workers toil away in the boiler room. (Courtesy of HSPA.)

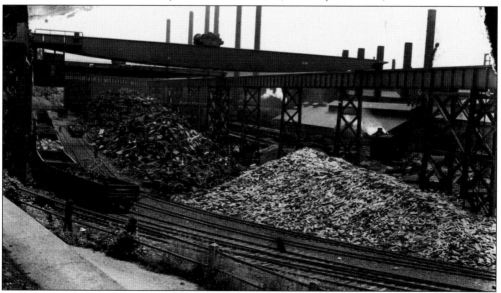

In the mid-1800s, Phoenix Iron Works had grown so vast it threatened to overwhelm Phoenixville, which saw its population quadruple from 1840 to 1848. In response, the company built about 100 modest homes on its land to house workers. Here even the scrap yard of the early 20th century was massive. (Courtesy of HSPA.)

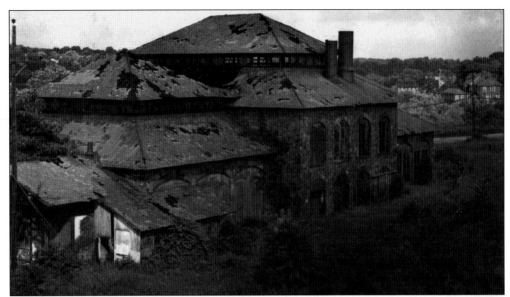

As the American steel industry began to dwindle in the late 20th century, Phoenix Iron Works went into decline. By 1986, production had ceased, the land was sold off, and most of the buildings were demolished. The foundry building is one of the only remaining structures. In this 1997 photograph, it was in great disrepair, but it has since been renovated and now serves as a heritage center. (Courtesy of HSPA.)

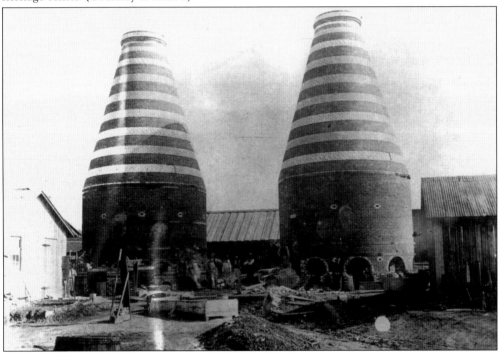

In 1867, owners of the ironworks started another successful company, the Phoenix Pottery, Kaolin, and Fire Brick Company. The company used kaolin—a pure form of clay found locally—to make firebricks for the ironworks furnaces. The clay was also good for making pottery, which was fired in kilns at Church and Starr Streets. (Courtesy of HSPA.)

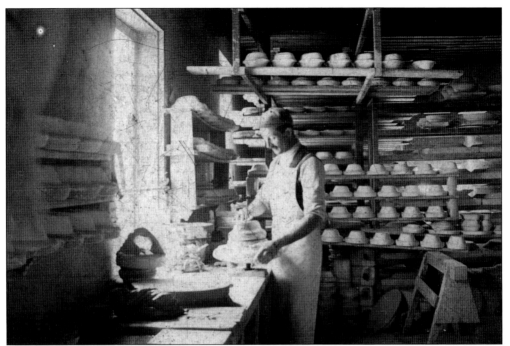

The pottery company later became known as Griffin, Smith, and Hill and in 1882 began manufacturing handmade Etruscan majolica pottery that featured high glosses and brilliant glazes. Here a potter is forming a bowl on a wheel. The firm also used devices to mold tableware and had steam engines for pressing and grinding pottery. (Courtesy of HSPA.)

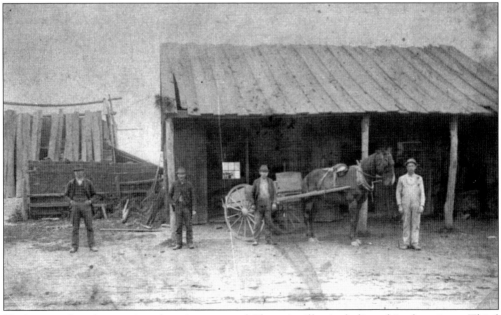

Kaolin was found in various locations around Phoenixville, including this clay pit on Third Avenue. In 1890, a fire damaged the main plant, which reopened four months later as Griffin Pottery. In 1894, the name changed again to Phoenix Pottery. The company changed ownership nine times after that, without ever making a profit, and closed in 1903. (Courtesy of HSPA.)

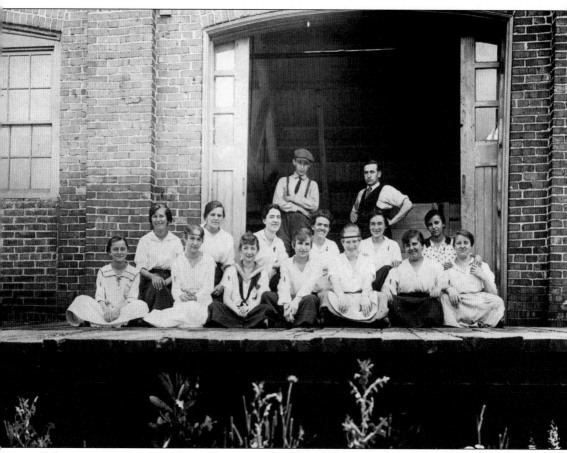

Like most river towns and cities, Phoenixville maintained a number of smaller factories, including textile mills. Here employees of the Bucks shirt factory take a break outside their workplace. (Courtesy of HSPA.)

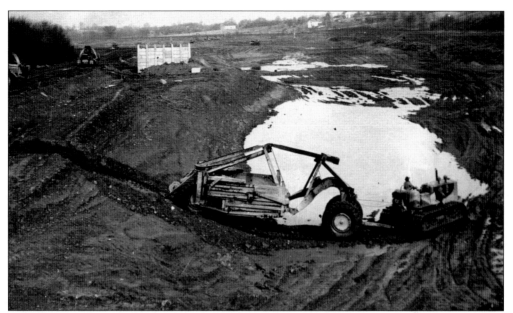

The $31.75 million government-funded Schuylkill River Desilting Project was undertaken from 1945 to 1954. The process of coal mining caused fine coal particles called culm to be washed into nearby waterways. In the early 1900s, the Schuylkill River took in over three million tons of culm annually. By 1930, the river and canal were choked with sediment, causing navigation and flooding problems and threatening the river's value as a water supply. The desilting project dredged silt from the river, pouring it into 27 specially constructed desilting basins. The photograph above shows a desilting basin being constructed. The concrete drainage weir on the left allowed water from the coal slurry to drain through an underground pipe back to the river. Below, a slurry of silt and water flows from a dredger's pipe into the basin. (Courtesy of SFAHS, photograph by Harold Amster.)

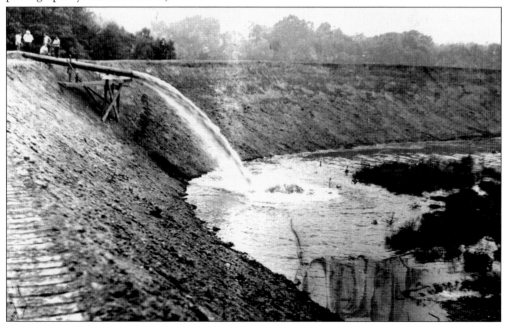

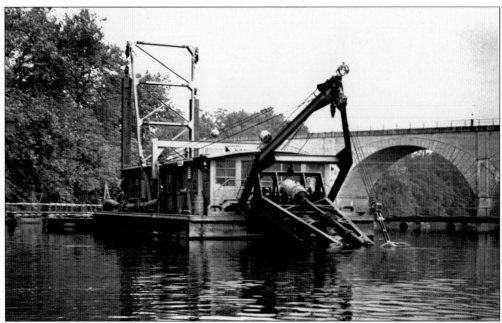

These two photographs, taken by Spring City photographer Harold Amster near an unidentified desilting basin, show the workings of a dredge that removed coal silt from the bottom of the river. The cutterhead at the front of the dredge, above, pumped a slurry of silt and water into a pipe, shown at right beside the bridge. The pipe led directly to the desilting basin. In the image below, a worker operates the levers that work the dredge. After the desilting project ended in the 1950s, sand, gravel, and coal were recycled. Today only three desilting basins are operational. (Courtesy of SFAHS.)

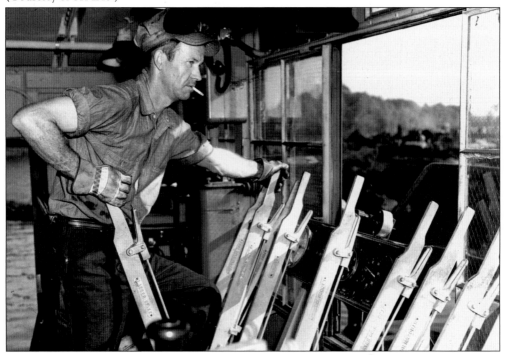

Five

SPRING CITY
TO POTTSTOWN

In 1893, Spring City was a busy canal town. This illustration shows the canal running behind houses and industries on South Main Street. On the right is the American Wood Paper Company. The canal bridge located just beyond the paper mill is near where a Turkey Hill Market is now located. Beyond that is a railroad bridge, with tracks leading up the hill to the Bennett Glass Works, top left. (Courtesy of SFAHS.)

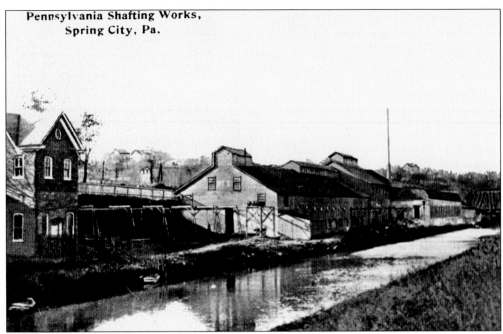

Pennsylvania Shafting Works,
Spring City, Pa.

The paper mill in the previous illustration was established in 1847 but shut down in 1894. The facility then housed the Pennsylvania Shafting Works, which later became the Keystone Drawn Steel Company. Other industries located along this section of the canal in the 19th century included the Spring City Stove Works, several brick works, and a foundry. (Courtesy of SCA.)

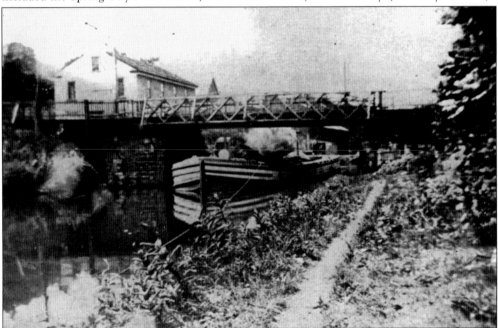

A barge moves through the canal in Spring City in this undated photograph, which identified the building as the Interborough Press building. A later postcard showed it with a sign reading Spring City Sun. The bridge carried traffic over the canal between Royersford and Spring City. (Courtesy of SCA.)

A swimmer uses a railroad trestle over the canal as a diving platform in the early 1920s. The bridge is the former Pennsylvania Railroad bridge located behind the Gruber Mills on South Main Street. It is still standing, although the Gruber Mills is now a housing development for senior citizens. (Courtesy of SFAHS.)

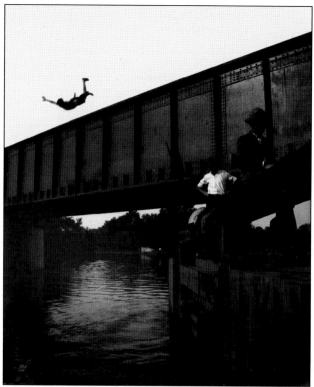

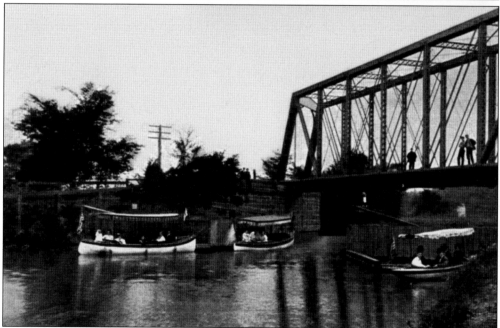

In this 1907 postcard, pleasure boats float below the Pennsylvania Railroad bridge in Spring City. This bridge was located near the property of the Pennhurst State School and Hospital for the mentally and physically disabled, which opened in 1908 on a 1,400-acre site overlooking the river. (Courtesy of SFAHS.)

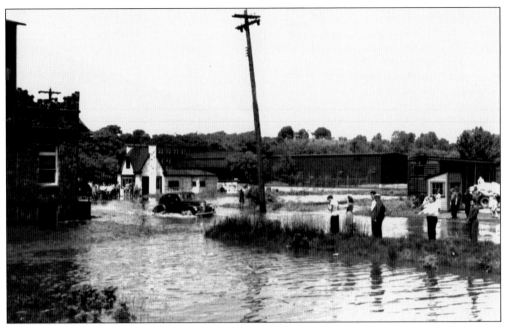

Like many river communities, Spring City has long been susceptible to destructive floods. In 1942, crowds gather to survey East Bridge Street, inundated after a major flood. The white building in the center was Gebhard's service station and restaurant. Behind it were baseball fields next to a rail yard. These fields were located in the floodplain and regularly took on water. (Courtesy of SFAHS.)

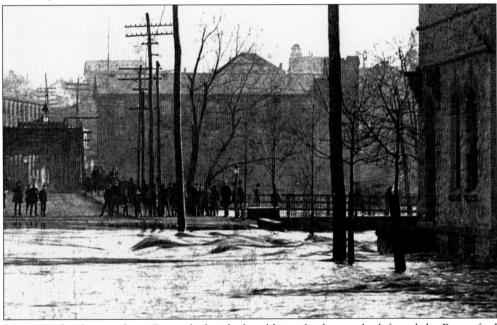

This 1902 flood scene shows Royersford with the old iron bridge on the left and the Royersford Spring Company beyond it. The railing before the bridge is part of what was once the Spring City Boardwalk that allowed people to walk above the floodplain. To the far right are the offices of the Urner Knitting Mill. (Courtesy of SFAHS.)

Just above Spring City in Parkerford was lock 57, or Schwartz's Lock, which served as the outlet lock of the Girard Canal. This *c.* 1902 photograph was taken from Crabbe Hill, and below it is the lock tender's house. On the left is an island that was removed during the Schuylkill River Desilting Project. (Courtesy of SCA.)

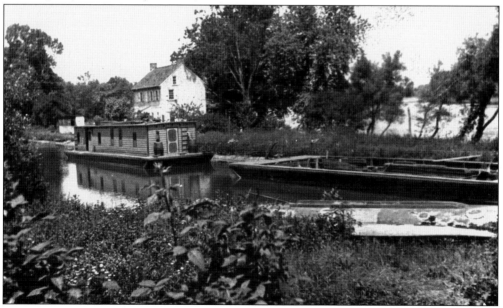

A mechanic's barge and lumber scow move through the canal near Schwartz's Lock in 1926. According to information with this photograph, the boats were "seen by Mrs. Ben Reitnour," who lived nearby. This part of the canal was known as the Girard Canal, the longest canal on the Schuylkill Navigation System. (Courtesy of SCA.)

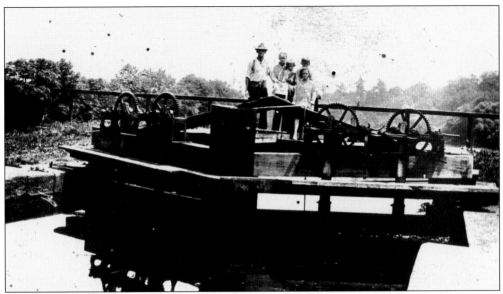

Charles Mull, pictured here with his children, was the lock tender at Schwartz's Lock from 1913 to 1920. Lock tenders were responsible for opening and closing the lock gates so that boats could move through the canal. (Courtesy of SCA.)

The Linfield covered bridge was a toll bridge that once joined Parkerford and Linfield. The house on the right is the toll keeper's house. Long before the bridge was constructed, George Washington's Continental army crossed the Schuylkill River at Parker's Ford, near this point, in September 1777 after the Battle of Brandywine. (Courtesy of SCA.)

Grace Razor, daughter of the last toll keeper, stands in 1930 in front of the dilapidated Linfield covered bridge, also known as the Lawrenceville Bridge. Constructed in 1849, it stood until 1933 when it was torn down. The tollhouse, not visible in this photograph, was off to the right. Today an iron bridge has been erected at this spot. (Courtesy of Limerick Township Historical Society.)

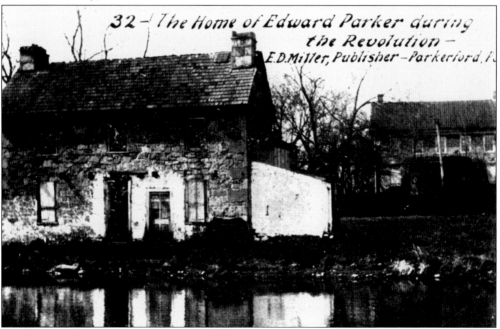

Parkerford Tavern, seen in the background, was built in 1766 by Edward Parker near a ford in the river. It served as a rest stop for travelers on the "Great Road" from Philadelphia to Reading and later along the canal, which in this photograph lies at the edge of Parker's house. George Washington once stayed at the tavern, which is currently being restored by East Vincent Township. (Courtesy of SFAHS.)

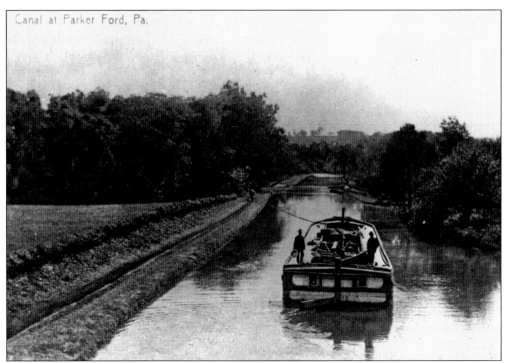

Canal barges were identified by name, and here the *Congress* from Manayunk is being pulled through the canal at Parkerford. The Pigeon Creek aqueduct is visible in the distance. An aqueduct was essentially a bridge that carried boats along the canal over a creek. It appears that a man is pulling the barge. In the early days, men rather than mules did, in fact, often pull barges. (Courtesy of SCA.)

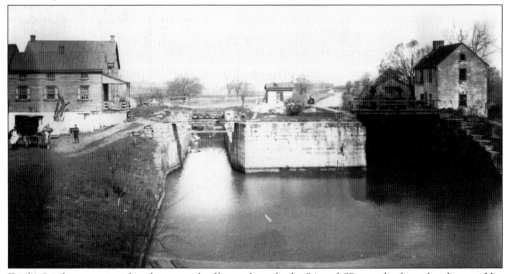

Frick's Lock was once a bustling canal village where locks 54 and 55 were built on land owned by a farmer named John Frick. Later it continued to thrive as a stop on the Pennsylvania Railroad. The construction of the Limerick Generating Station in the 1970s and 1980s required the evacuation of the village. Today there is a movement to preserve several abandoned buildings that remain. (Courtesy of SCA.)

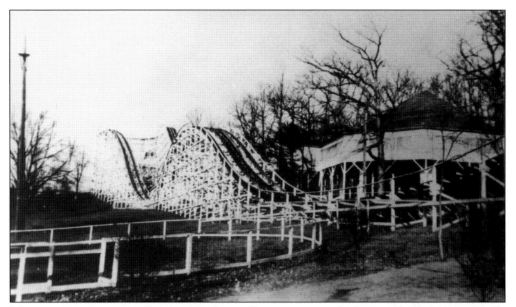

Like many communities, Sanatoga in Lower Pottsgrove once had a popular amusement park, Sanatoga Park, which operated from the late 1800s until 1940. The roller coaster shown here was a popular attraction. When the park shut down, the wooden coaster was dismantled and allegedly used to start the A. D. Moyer lumber company. (Courtesy of LPHS.)

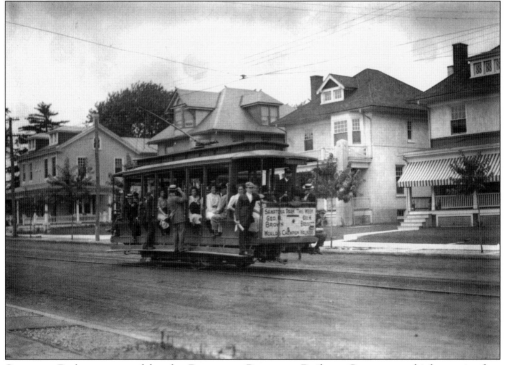

Sanatoga Park was owned by the Pottstown Passenger Railway Company, which ran its first trolley there on July 1, 1893, and carried 118,000 people to the park during the first 35 days. In this c. 1920s photograph, trolley No. 1 has standing room only. (Courtesy of LPHS.)

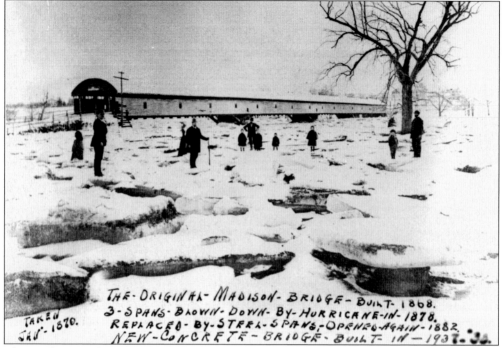

THE·ORIGINAL·MADISON·BRIDGE·BUILT·1868.
3·SPANS·BLOWN·DOWN·BY·HURRICANE·IN·1878.
REPLACED·BY·STEEL·SPANS·OPENED·AGAIN·1882.
NEW·CONCRETE·BRIDGE·BUILT·IN—1937.

TAKEN JAN. 1870.

The Madison Bridge spanned the river between Pottstown and North Coventry. According to information on this wintry photograph, the bridge was built in 1868 and partially washed away during an 1878 hurricane. It is now the site of the Keim Street Bridge. (Courtesy of PHS.)

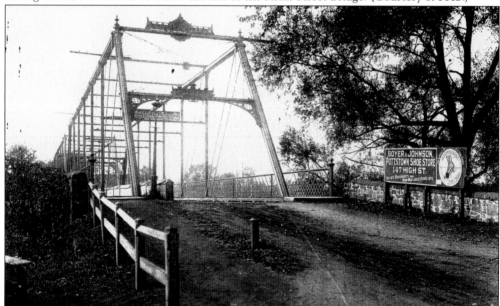

The Hanover Street Bridge, connecting Pottstown to North Coventry along Hanover Street, was a toll bridge, and people were charged half a cent to cross it. Many avoided the charge in winter by crossing on the ice. This c. 1899 photograph shows a sign for the Boyer and Johnson shoe store on High Street. This bridge was washed away in 1972 and replaced with the existing bridge. (Courtesy of PHS.)

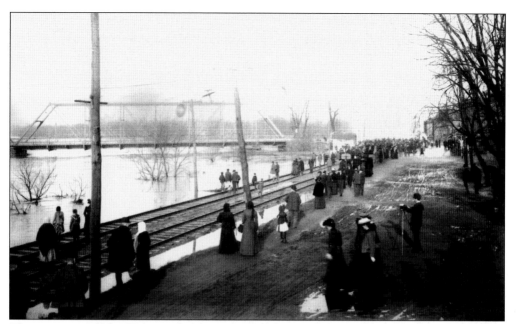

The area around the Hanover Street Bridge has long been subjected to floods. In this 1902 photograph, crowds gather along what is now Industrial Boulevard to peruse the flooded waterway. The 1902 flood wreaked havoc along the canal and in towns up and down the river. (Courtesy of PHS.)

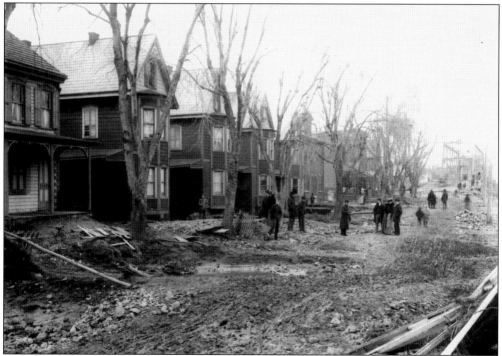

This photograph, perhaps taken the same day as the image above, shows the extensive damage along the North Coventry side of Hanover Street. It appears that the river washed through the street, knocking down fences and dropping debris in its path. (Courtesy of PHS.)

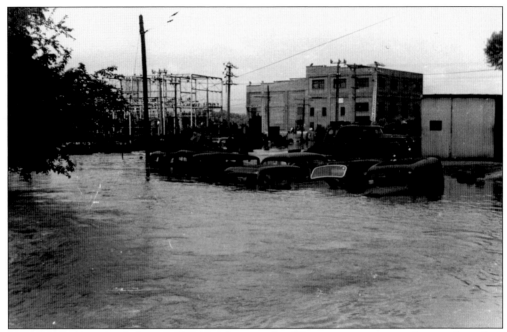

In 1942, the area flooded again. In this photograph of Pottstown, cars are submerged to their windshields along what is now College Drive. In the background is the former PECO substation, today the renovated headquarters of the Schuylkill River National and State Heritage Area. (Courtesy of THS.)

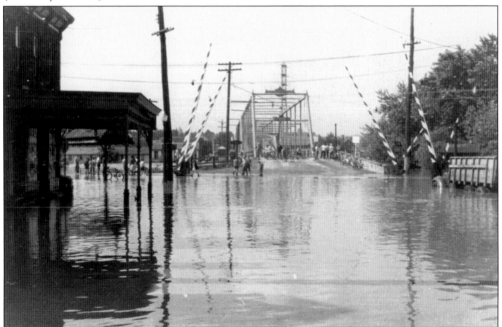

Also taken during the 1942 flood, this image shows the iron Hanover Street Bridge and, to the left, the former P&R station that once stood at the corner of Industrial Boulevard and Hanover Street. It was demolished, and the property later held the Mrs. Smith's Pies building, once a major Pottstown industry. (Courtesy of THS.)

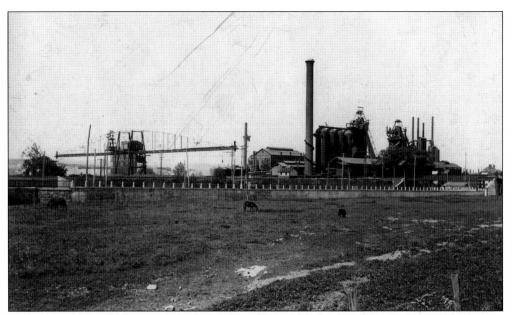

The Warwick Iron Company was built in 1875 on the south side of High Street, west of Manatawny Creek in an area called "Death Valley" for the many industrial accidents that occurred there. It became one of the most successful iron furnaces in the Schuylkill Valley. In 1912, it was leased to Eastern Steel Company of Pottsville and remained successful through World War I but shut down in the 1920s. (Courtesy of PHS.)

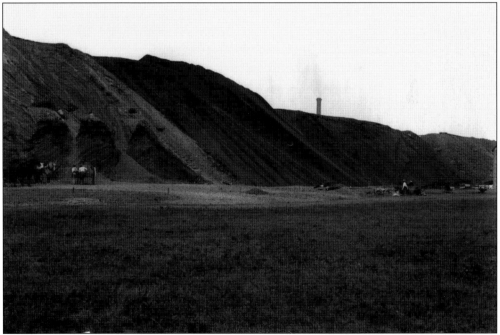

The cinder pile from the Warwick Iron Company was once high enough to dwarf the horse and wagons shown in this photograph. The nighttime dumping of the waste slag from the furnaces once lit up the night sky for miles around. This area is now in Pottstown's Keystone Opportunity Zone. (Courtesy of PHS.)

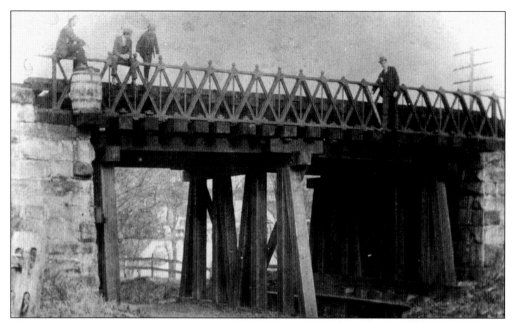

America's first iron truss bridge was created by Richard Osborne, an ironworker at Pottstown's P&R blacksmith shop. Osborne realized that a bridge made solely of iron would bear the load of coal-laden trains better than earlier bridges. Known as the Manayunk Bridge, it crossed a small creek below Flat Rock Tunnel. Parts are now on display at the Smithsonian National Museum of American History. (Courtesy of SCA.)

Jacobs Aircraft Engine Company came to Pottstown in 1932 and within several years became a leader in commercial sales of 200- to 400-horsepower engines. It later produced twin-engine aircraft used during World War II. This photograph shows the parts department of the repair shop, once located on Queen Street. (Courtesy of PHS.)

Arthur St. Clair, a Revolutionary War general, lived in this Pottstown house when he was elected president of the Confederation Congress in 1787. The home once stood at the southeast corner of High and Hanover Streets and was known as the Arthur St. Clair house until it was demolished in the 1940s. The engraving of St. Clair at right dates from the mid-1800s and was from an original portrait by Charles Wilson Peale. (Above, courtesy of PHS; right, courtesy of Kurt D. Zwikl.)

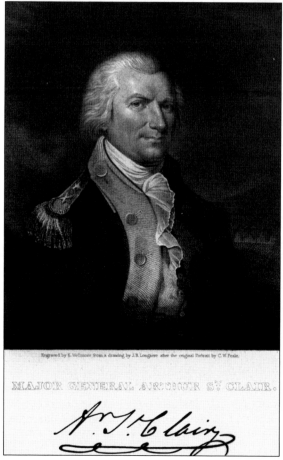

Engraved by E. Wellmore from a drawing by J.B. Longacre after the original Portrait by C.W Peale.

MAJOR GENERAL ARTHUR ST CLAIR.

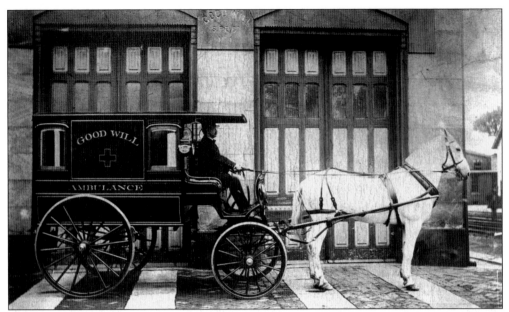

Good Will Steam Fire Engine Company No. 1 first organized in 1871 and began providing horse-drawn ambulance service to transport the sick and injured in 1891. When this undated photograph was taken, Good Will, which still serves the Pottstown community today, was located on the east side of Hanover Street, near the railroad tracks. It moved to its current High Street site in 1956. (Courtesy of HSMC.)

The area around Pottstown was once a farming community. Here men gather for an auction at stables on Charlotte Street, facing High Street. The entrance of the farmers' market is seen on the left. In the foreground is a former arcade that once housed a roller rink. (Courtesy of PHS.)

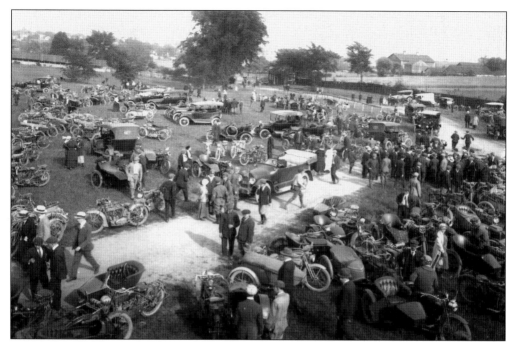

This racetrack once provided a popular form of entertainment for area residents. Built in 1874 for horse races, Mill Park attracted as many as 10,000 people a day. It was later used for car and motorcycle races, as pictured here in 1915. Today this area is located roughly around what is now the parking lot for Wal-Mart in Pottstown. (Courtesy of PHS.)

The Schuylkill Canal once ran along the river in North Coventry. This section of the canal was known as the Girard Canal and spanned from Reading to Parkerford. This photograph shows one of two locks (52 or 53) known as Laurel Locks, where the canal ran through Laurel Locks Farm. (Courtesy of LLF.)

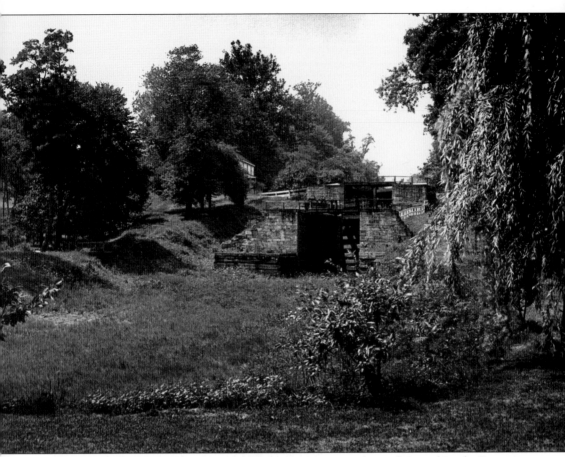

This 1927 photograph shows the lock channel after it was drained. Laurel Locks Farm owners later created a garden in the lock channel. Today the remains of the lock are still visible on Laurel Locks Farm. The farm, which is privately owned, was established in 1739, and a number of historic structures still stand, including the 1828 lock tender's house. In addition to transporting coal, the canal also hauled farm equipment from Philadelphia to the towns along the route and carried back grain and other agriculture products. (Courtesy of LLF.)

Six

DOUGLASSVILLE TO EXETER

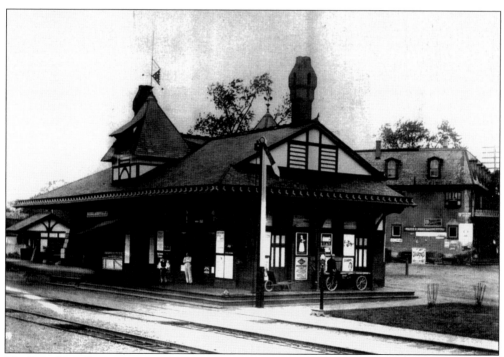

The Douglassville train station was once a stop on the P&R. In the background, the Douglassville Hotel can be seen. The hotel is still standing and serves as a local restaurant. The train station is gone, and the Schuylkill River Trail now follows the route where the tracks once lay. (Courtesy of AHS.)

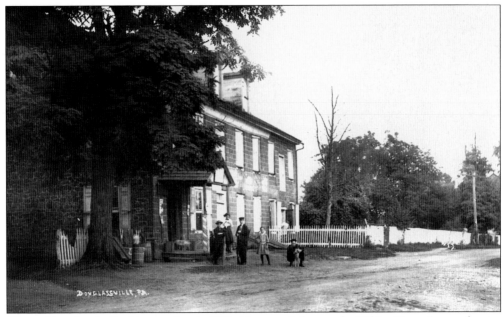

George Douglass built this mansion in 1763. He owned the nearby White Horse Inn and ran a store that dealt in iron from nearby forges. In the early 1900s, the mansion housed a restaurant and barbershop. Today it is owned by the Historic Preservation Trust of Berks County and is part of Historic Morlatton Village, which also includes Berks County's oldest home. (Courtesy of AHS.)

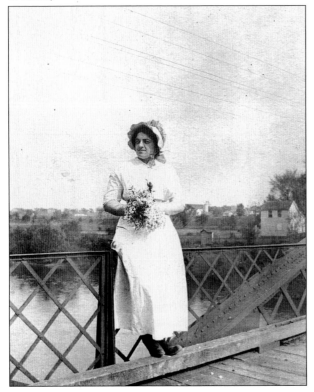

This bridge spanned the river between Monocacy and Union Township in the 1920s. The woman in the photograph is Vesta Kline, on what is thought to be her wedding day. (Courtesy of AHS.)

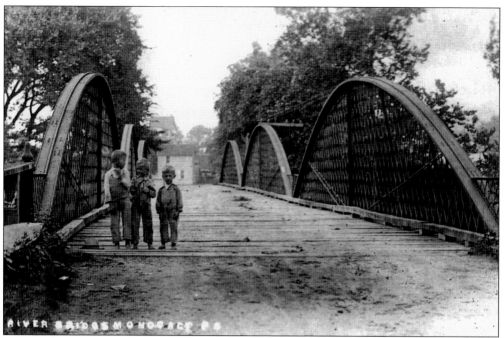

This is another view of the Monocacy Bridge. Here three young boys pose along the entrance to the bridge in the 1920s. They have been identified as, from left to right, Samuel, Bill, and Raymond Manmiller. (Courtesy of AHS.)

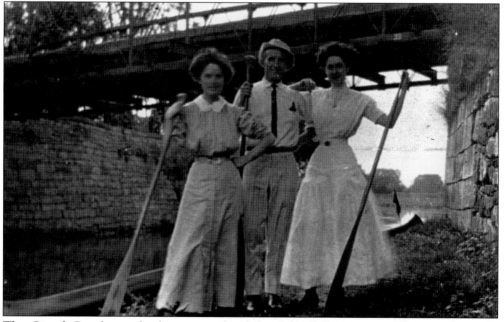

The Girard Canal was the longest reach of the Schuylkill Navigation System, stretching 22 miles between lock 50 just below Reading to lock 57 in Parkerford. In this August 23, 1910, photograph, two women and a man stand beside their canoe beneath what was known as Bells Bridge, or bridge No. 33 on the canal, located between Monocacy and Birdsboro. The area is identified on the photograph as "Bland's Turn." (Courtesy of AHS.)

In this image of the canal between Gibraltar and Birdsboro, the Indian Corn Creek aqueduct is visible, and beyond it is a wooden bridge that crossed the canal. (Courtesy of HSPA.)

Birdsboro was founded by William Bird, who established an iron forge along Hay Creek in 1740. The Bird properties were purchased by Matthew Brooke in 1796, and his two sons took over in 1837 and organized the E and G Brooke Iron Company. This photograph shows a store at the southwest corner of Main and Mill Streets, which was built in 1875 as the E and G Brooke Iron Company Mercantile building. (Courtesy of AHS.)

William Bird's son Marcus built a furnace on French Creek at Hopewell that ran from 1770 to 1883. It was America's largest producer of iron during the Revolutionary War. This 1887 photograph, later made into a postcard, shows the stone furnace, wheelwright shop, cast house, and ore roaster. The buildings have since been restored, and Hopewell Furnace is now a national historic site. (Courtesy of National Park Service and Thomas C. Keim.)

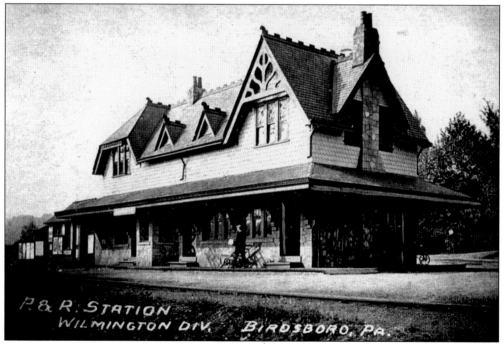

Frank Furness was the chief architect for the P&R and a prominent designer of many of the region's more decorative buildings. The Birdsboro station displays the Victorian detail that typified much of Furness's work. (Courtesy of Thomas C. Keim.)

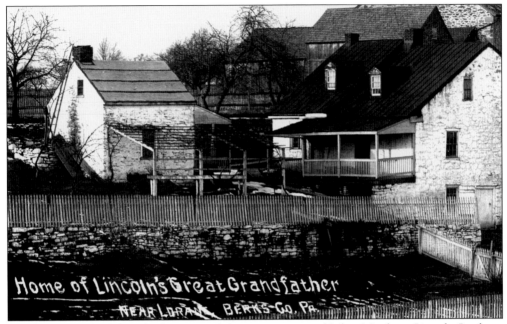

Home of Lincoln's Great Grandfather
NEAR LORANE, BERKS CO, PA.

This house was built by Abraham Lincoln's great-great-grandfather Mordecai Lincoln Jr. about 1733. Mordecai was an ironworker who came to Chester County from New Jersey in 1720 and later purchased 1,000 acres east of the Schuylkill River in Exeter Township. Abraham Lincoln's great-grandfather and grandfather lived in the house, which still stands and is privately owned. (Courtesy of AHS.)

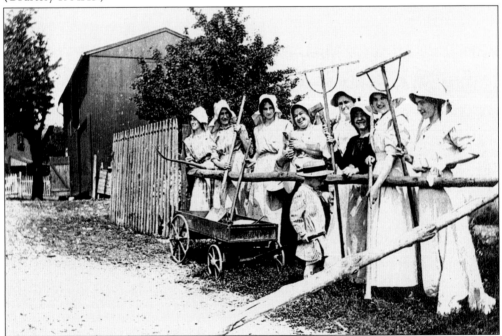

Farms once dotted the region around Reading. Here a group of women poses before a farm located at 1100 South Ninth Street in Cumru Township. The farm still exists today as a horse farm. (Courtesy of AHS.)

Seven

READING TO
SHOEMAKERSVILLE

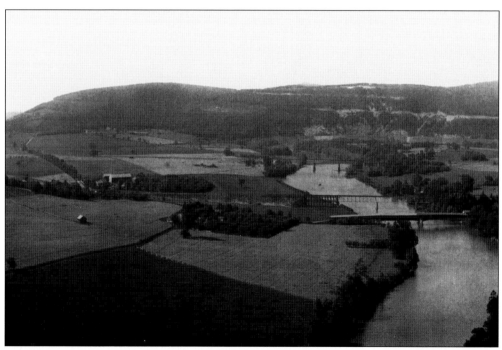

This 1891 view of the Schuylkill River looks north from Ridgewood, just beyond the horseshoe bend the river takes in Reading. The three bridges are, from front to back, the covered Poplar Neck Bridge, the Reading Railroad bridge (originally built for the Wilmington and Northern Railroad), and the Pennsylvania Railroad bridge. Neversink Mountain is in the background. (Courtesy of HSBC.)

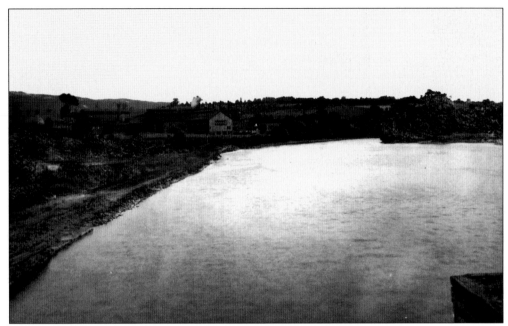

The Carpenter Steel Company was founded in 1889 by James H. Carpenter, an engineer who leased an old P&R rail mill in Reading and began producing steel. The air-hardening steel that he developed established the company as a steel pioneer. Shortly after opening, Carpenter moved his firm to the site in this 1891 picture, formerly the Union Foundry. Today it remains a successful firm in Reading. (Courtesy of HSBC.)

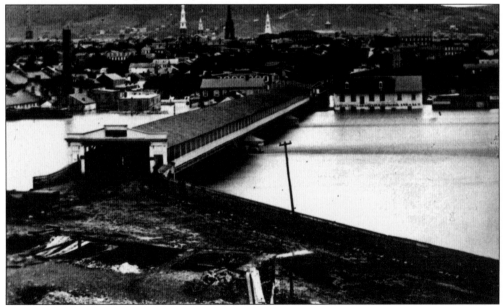

This 19th-century photograph shows the river at flood stage, with the Penn Street wooden covered bridge in the center. The canal, its towpath underwater, is on the far side of the river. On the left is the tower of the O'Brien-Bushong Distillery, and to the right of the bridge is Dr. Benson's steam-powered flour mill. Both, partially submerged, were located along the canal. (Courtesy of HSBC.)

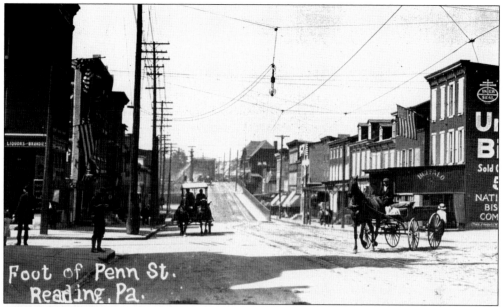

Here the Penn Street iron bridge can be seen in the background. Just before it, on the right, is the old Pennsylvania Railroad depot. The wooden bridge stood from 1851 to 1884 when the Pennsylvania Railroad replaced it with an iron bridge due to fears that trains running beneath it would spark a fire. The iron bridge was replaced in 1914 by the Penn Street viaduct. (Courtesy of HSBC.)

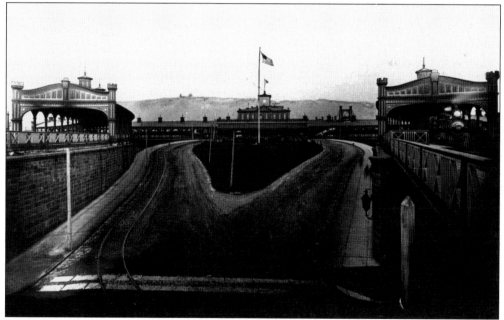

Reading Outer Station, located on Sixth and Oley Streets, was built in 1874 within a triangle of railroad tracks leading in seven directions. The building featured a clock tower, with faces in four directions, and a second floor that housed the local railroad's business offices. By the end of the 19th century, 70 passenger trains came through daily. No longer used after 1969, it was destroyed by fire in 1978. (Courtesy of HSBC.)

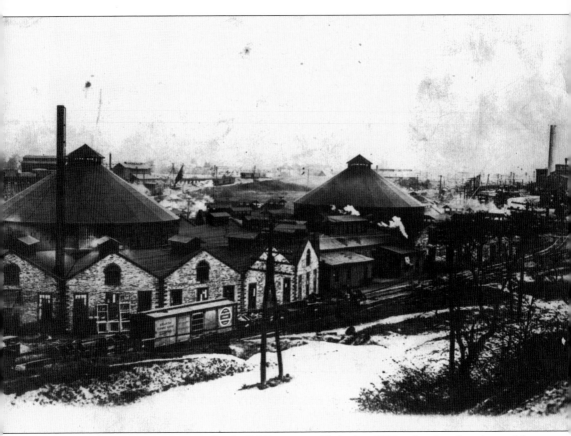

The Reading Company, originally the P&R, was established in 1833 to haul anthracite coal from Reading to Philadelphia. Beginning as a modest 94-mile line, it grew to a 1,400-mile system and by 1871 was the richest corporation in the world, worth $170 million. Although its headquarters were in Philadelphia, the main production and repair shops were in Reading. The Reading Company yards was a massive 36-acre production and engineering complex that comprised much of Reading's downtown and transformed it into a boomtown. This photograph shows the turntable and part of the roundhouse that were central features of the Reading Company yards. (Courtesy of HSBC.)

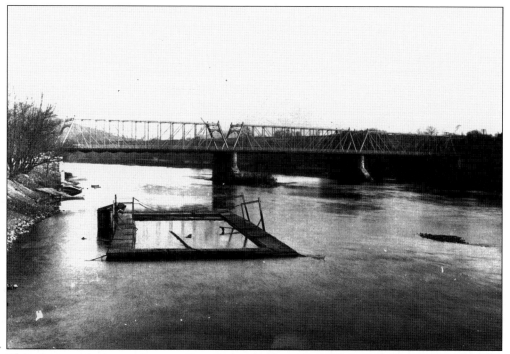

This photograph shows what was identified as Professor Besser's private swimming pool in the river, with the Bingaman Street Bridge in the background. The iron bridge replaced an earlier 585-foot-long covered bridge at that location, and in 1921, the iron bridge was replaced by a new concrete bridge. (Courtesy of HSBC.)

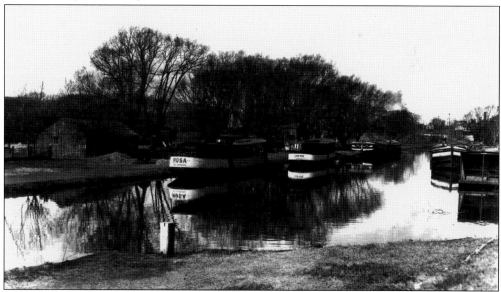

Hiester's excursion boats, the *Carrie* and *Rosa*, took people along the river in Reading from the late 1800s through 1917. The boats, seen here in 1904, are moored at Jackson's Lock (lock 48), at the southern tip of "long island," which was formed when the canal separated a strip of land from Franklin Street to the end of Sixth Street. Today Reading Area Community College stands on land that was once part of the island. (Courtesy of HSBC.)

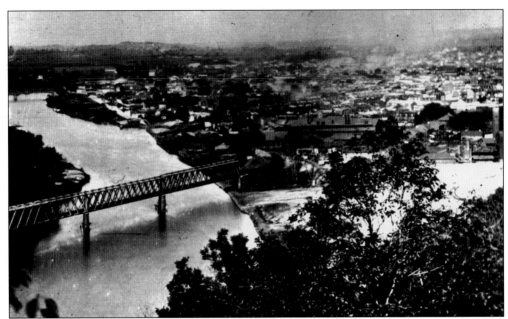

This photograph taken from Neversink Mountain shows the Pennsylvania Railroad's Schuylkill Valley branch bridge crossing the river with the large plant of the Reading Iron Company on the right. Beyond the bridge, Jackson's Lock is visible as is the canal that formed "long island." (Courtesy of HSBC.)

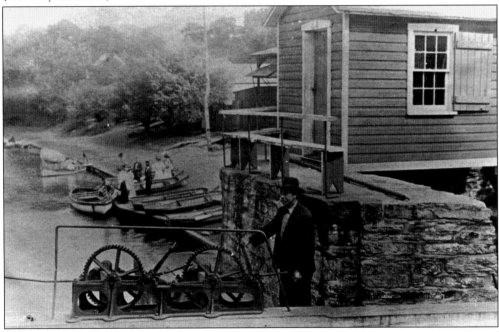

Lock 44 was located just above Reading at what was known as Shepp's Dam. A number of rowboats in the background show that this portion of the canal was being used primarily for recreation when this photograph was taken, sometime in the early 1900s. To the left is the lock tender's shanty, which stored equipment and records. The lock tender here is preparing to use the wicket that opened and closed the lock. (Courtesy of HSPA.)

The Reading area contained several mule sheds, where mules that pulled canal barges were housed and cared for. Here men are shoeing the mules. The young boy in the center is holding a tail switch to chase away flies. (Courtesy of HSBC.)

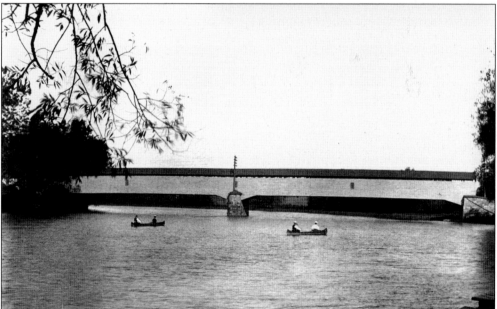

Three miles north of Reading, Leize's Bridge was a covered toll bridge that spanned the river between Muhlenberg and Bern Townships. Built in the 1800s, it provided an important crossing point for many years. It burned in 1952. This was one of many covered bridges that crossed the river in the late 19th century. A total of 45 were constructed in Berks County between 1834 and 1885. (Courtesy of HSBC.)

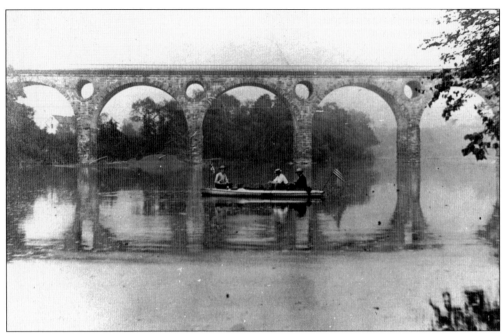

Peacock's Bridge, named for its location near Peacock's Lock, crosses the river four miles north of Reading. Built in 1855 by the Reading Railroad, it features nine stone arches, with round openings set between them that create a beautiful distinctive design. The bridge is still in use today. (Courtesy of HSBC.)

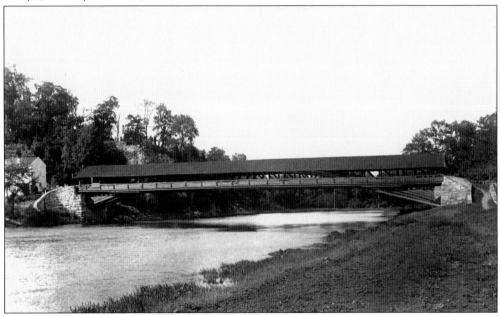

The 240-foot-long Stoudt's Ferry Bridge was once the longest single-span wooden covered bridge in the world. It was built in 1857 about six and a half miles north of Reading, by the Schuylkill Navigation Company, to allow mules to pull barges across the Schuylkill River. The canal at this point shifted from one side of the river to the other. In 1948, it collapsed and fell into the river. (Courtesy of HSBC.)

The seven-story red brick-and-tile Pagoda is now a Reading landmark. It was built on Mount Penn in 1908 by William Abbot Whitman following complaints that his quarrying operation defaced the hillside. Intended as a luxury resort, it failed to open when Whitman was unable to obtain a liquor license. A prominent businessman took it over and later sold it to the City of Reading for $1. (Courtesy of HSBC.)

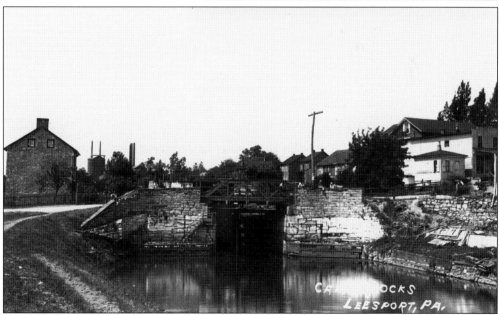

This 1910 postcard of Leesport shows the Wall Street Bridge over the canal at lock 37. The canal here has been filled in, but the locks are visible beside the restored lock tender's house. The locks, located near a canal dock and several large grain warehouses, made Leesport important to farmers, who once lined up for miles to buy and sell goods here. (Courtesy of LLHF.)

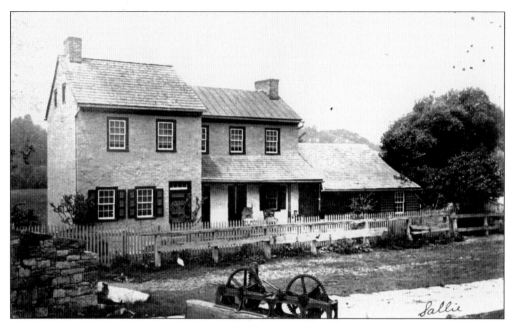

The Leesport Lock House dates back to 1840. The last lock tender to live here was Augustus Menard, who had 17 children and died in 1922. He and his wife, Mary, ran a restaurant for travelers from the small addition on the right. Reportedly, they also took in lodgers, so the children slept in the attic. The house has since been restored and is owned by Berks County. (Courtesy of LLHF.)

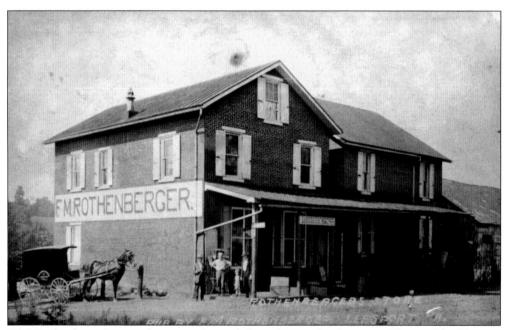

F. M. Rothenberger's general store was located along the canal in Leesport. The small building on the side served as an icehouse for ice harvested from the canal. Later a brick icehouse, insulated with cork, replaced it. (Courtesy of LLHF.)

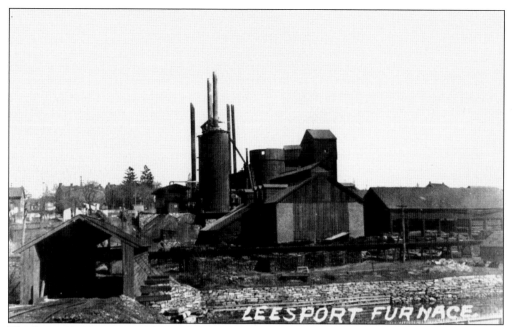

The Leesport Furnace was located along the canal between Centre Avenue and Canal Street and operated from 1853 to 1914. The covered bridge on the left took freight trains across the canal to and from the furnace. (Courtesy of LLHF.)

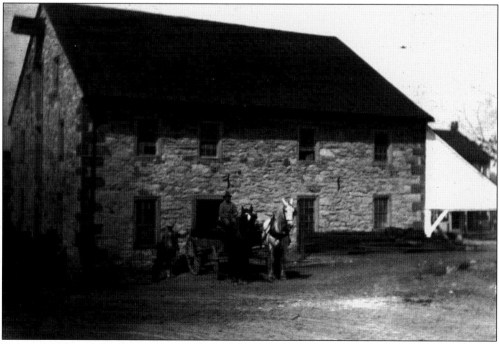

Known as Reeser's Mill, this grain mill dates back to Colonial times when it allegedly supplied flour for George Washington's troops during their winter at Valley Forge. During the 18th and 19th centuries, there were several mills in Leesport that served farmers from the surrounding areas. The presence of the mills and the canal made it a center for trade. (Courtesy of LLHF.)

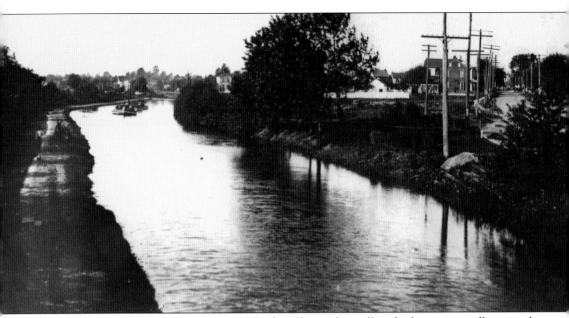

Lock 33 of the Schuylkill Canal was located in Shoemakersville, which was reputedly a popular place for boat captains to spend the winter when the canal was frozen over. The borough is named for Charles Shoemaker, who in 1768 opened a tavern along Plum Creek. Later, after the canal opened, Boatman's Hall was built near lock 33, providing a place for boatmen to rest and buy groceries, liquor, and other supplies. (Courtesy of HSPA.)

Eight

HAMBURG TO POTTSVILLE

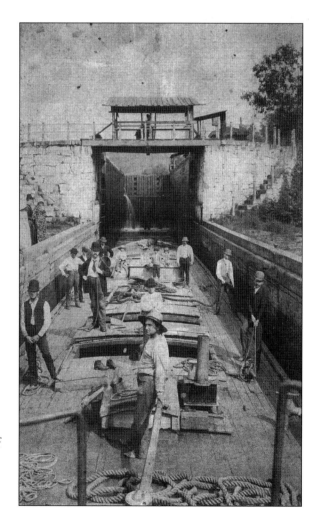

The Schuylkill Canal was changed and enlarged several times to allow for larger boats that could carry more coal. This photograph shows a group of boatmen and some family members at Five Locks, two miles below Hamburg. The combination of five locks that this area was named for was replaced by a system of two locks (31 and 32) in 1846. (Courtesy of HSBC.)

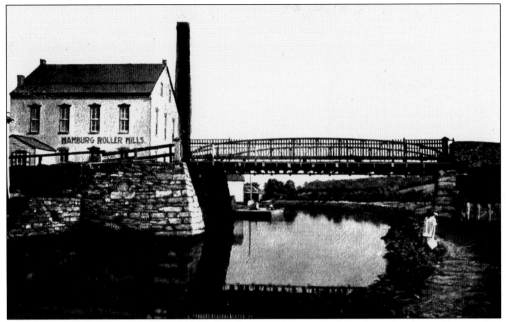

With the opening of the Schuylkill Canal in 1820, the borough of Hamburg became a boomtown. Industries took advantage of the waterpower, transportation, and easy access to fuel that the canal provided. The Hamburg Roller Mills is seen here just beyond the state highway bridge over the canal. (Courtesy of HAHS.)

Hamburg's first King Frost Carnival took place in 1910, as costumed residents celebrated fall. Today the King Frost Parade remains a popular festivity. Here the Windsor Broom Company, which was originally located along the canal, celebrates with a horse-drawn float featuring brooms and a witch. Brooms are still manufactured in the town by Hamburg Industries. (Courtesy of HAHS.)

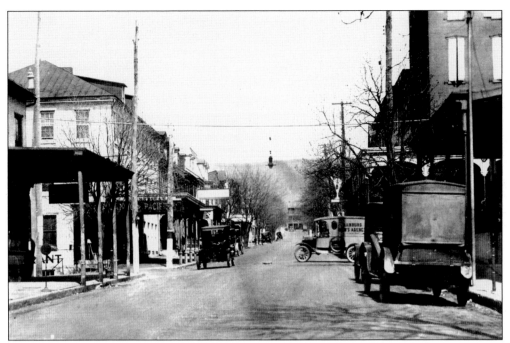

In the 1920s, Hamburg's downtown was thriving. Here early cars travel through the intersection of Fourth and State Streets. Today downtown Hamburg retains much of its historic character, and the over-the-sidewalk porticos seen in this picture add to the town's charm. (Courtesy of HAHS.)

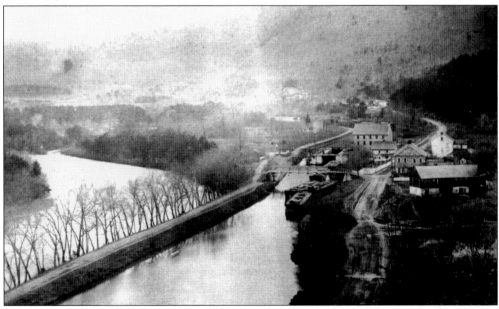

Kalbach's Lock (lock 30) was located by the Little Blue Mountain Dam, at the head of the Hamburg Canal in Kernsville. This section of the canal was drained in 1935, and a new Kernsville Dam was later built as part of the Schuylkill River Desilting Project. The Kernsville Dam desilting basin, one of only three operational desilting basins today, is now located at this site. (Courtesy of HAHS.)

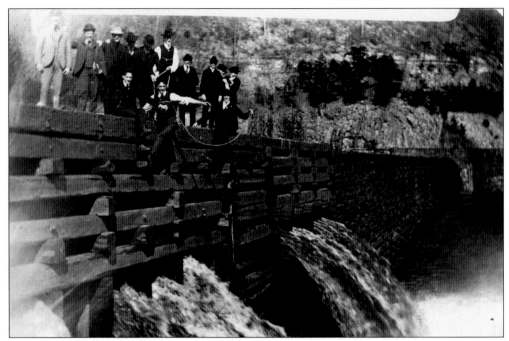

Just upriver from the Little Blue Mountain Dam was the Big Blue Mountain Dam. The highest of all dams on the canal at almost 25 feet, it created a slack water pool that extended up to Port Clinton. The dam featured wooden wickets that, when opened, allowed the dam pool to be drained. (Courtesy of HAHS.)

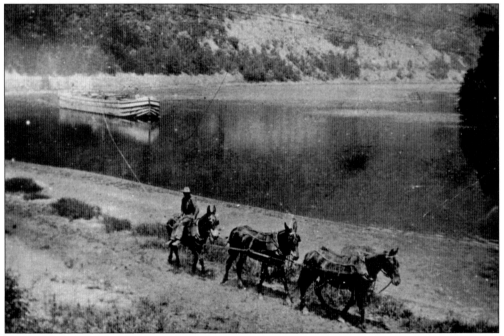

In this 1906 photograph, a team of mules pulls a canal barge through the dam pool of the Big Blue Mountain Dam near Port Clinton. Mule teams typically consisted of three mules that worked together to pull and guide the boats. (Courtesy of HAHS.)

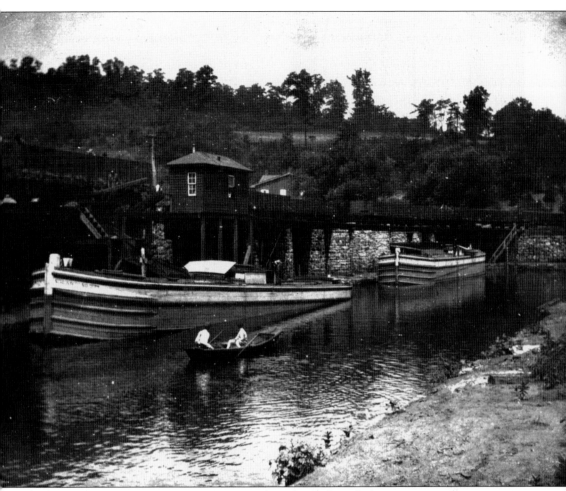

Port Clinton, which lies between the Little Schuylkill and the main river, was once an important canal center. In 1888, after the loading docks of Port Carbon and Schuylkill Haven were abandoned due to coal siltation, Port Clinton formed the head of the canal. From January through mid-March, when the canal was frozen over, many boatmen lived in Port Clinton, remaining on the boats with their families. (Courtesy of HSSC.)

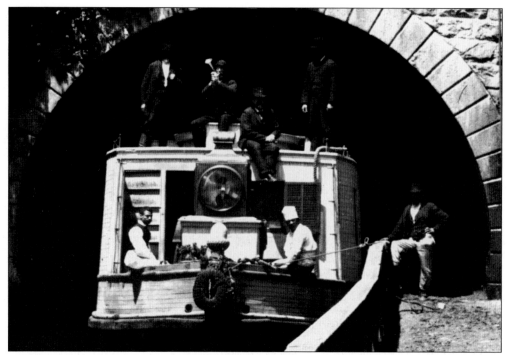

America's first canal tunnel was built between 1818 and 1819 along the Schuylkill Canal near Landingville, measuring 450 feet long. It was shortened several times and later removed. Boatmen poled the boat through while mules walked over the top. Typical boat crews included a bowsman, responsible for the tug line, who also served as a cook. Horns were used to alert lock tenders and, shown here, approaching boats. (Courtesy of OHS.)

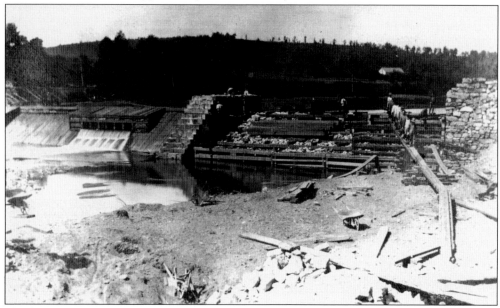

Floods were sometimes disastrous for the canal, destroying dams, barges, and locks. Here Lord's Dam, below Auburn, is being rebuilt in 1903 after a section was washed out in a flood. (Courtesy of HSPA.)

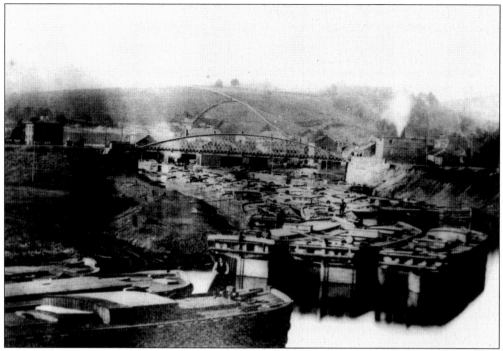

Schuylkill Haven, located just below the confluence of two branches of the Schuylkill River, served as an important coal-loading depot through 1888, when coal silt clogged the northern portion of the canal. In this 1878 photograph, boats are lined up at Broadway Bridge, which connected Dock Street with the Irish Flats. On the left is the canal company office building, which stood on Coal Street. (Courtesy of HSSC, photograph by H. S. Paul.)

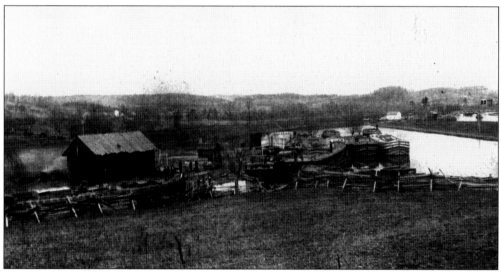

Schuylkill Haven boasted one of the biggest loading docks along the canal and also had several boatyards where the barges were built and maintained. This photograph shows Warner's Boatyard, where a large boat, left, is under construction and a number of boats are lined up for repairs. (Courtesy of HSSC.)

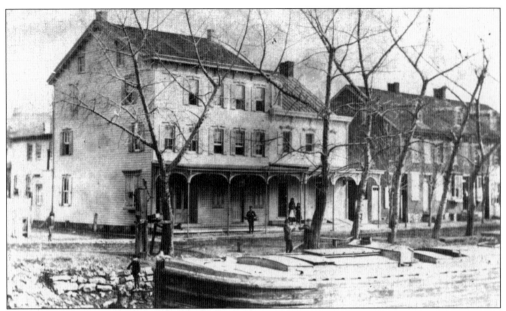

Water levels in the canal were drained in the winter. Here, in 1885, a barge sits in the dry canal basin in front of Motzer's Bakery and Mengel's Butcher Shop in Schuylkill Haven along Canal Street. The parkway is now at this location, with the grassy area in the middle covering the old canal bed. (Courtesy of HSSC.)

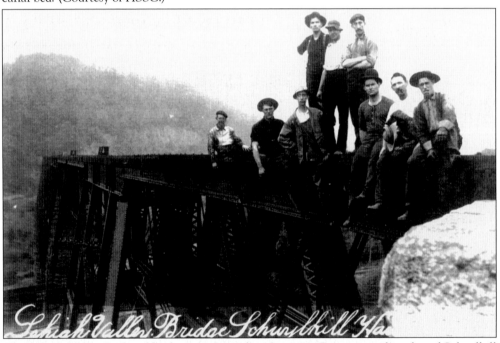

The Lehigh Valley Railroad bridge was erected at Conner's Crossing at the edge of Schuylkill Haven in 1890. The men sitting atop the bridge in this undated photograph are probably working on either construction or repair of the trestle. The bridge no longer stands, although portions of the stonework are visible. The river's path was shifted slightly at this location to allow construction of the Cressona Mall. (Courtesy of OHS.)

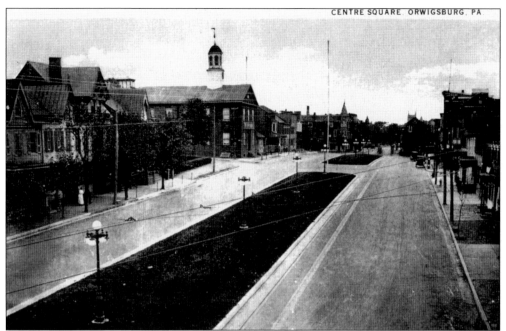

While the borough of Orwigsburg was not located along the river, early canal boats were constructed in this town and taken on wheels down to Landingville. When Schuylkill County was formed in 1815, Orwigsburg was chosen as the county seat. However, the town never became a booming center, and in 1851, the county seat was moved to the flourishing city of Pottsville. (Courtesy of OHS.)

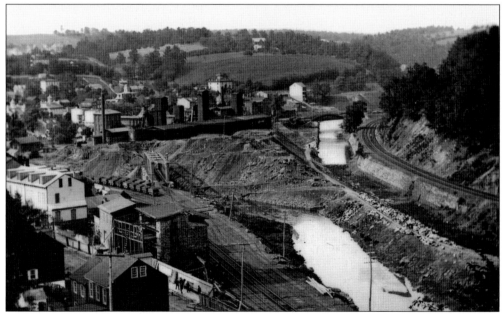

In 1795, the first iron furnace fueled by anthracite coal was established along the Schuylkill River. Eleven years later, John Potts purchased it and founded the city of Pottsville, which grew into a hub for coal and industry. This *c.* 1890 photograph shows Centre Street, bottom left, Pioneer Furnace, center, and the canal, right. (Courtesy of HSSC.)

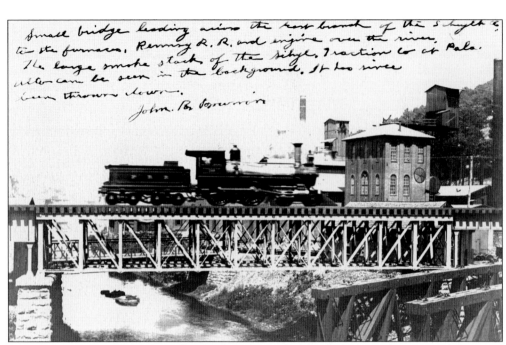

Pioneer Furnace was located on what was known as "the island," because the river and the canal formed an island of land around it. Here a steam locomotive pulls a car over the east branch of the river. According to writing on the photograph, the smokestack in the background belonged to the Schuylkill Traction Company in Palo Alto. (Courtesy of HSSC.)

The first run of a P&R (later known as the Reading Railroad) train from Pottsville to Philadelphia occurred in January 1842. The competing Pennsylvania Railroad extended into Pottsville in 1886 and flourished, transporting both passengers and freight. Here laborers of the Pennsylvania Railroad lay tracks along Coal Street in 1886. (Courtesy of HSSC.)

David Yuengling established a brewery on Centre Street in 1829. The facility was destroyed by fire and moved to Mahantongo Street, where beer was chilled in caves dug into Sharp Mountain, behind the brewery. Still family owned and operated today, Yuengling has, nevertheless, changed quite a bit since the days when kegs were transported by horse-drawn wagons. (Courtesy of HSSC.)

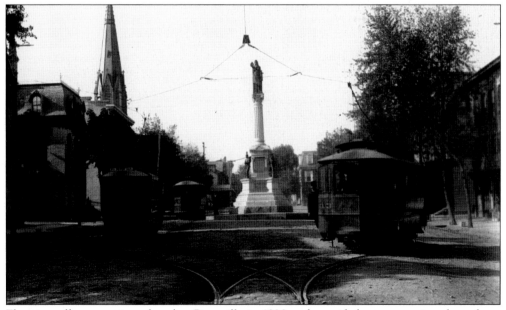

Electric trolleys were introduced to Pottsville in 1890 and provided transportation throughout the area until about 1932. Here three cars are parked before the Civil War Soldiers and Sailors Monument, shortly after it was dedicated in October 1891. (Courtesy of HSSC.)

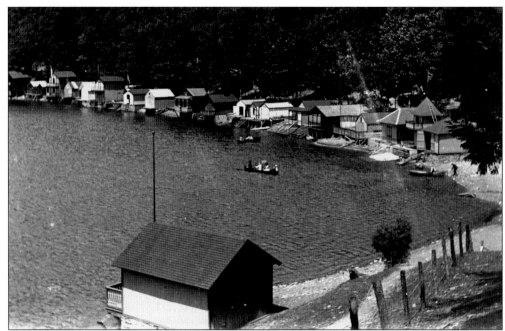

Tumbling Run was a man-made lake formed by two dams built by the Schuylkill Navigation Company around 1833 to supply water to the Schuylkill Canal. It grew to become a popular resort and recreation area. Along the shore of the second dam, nearly 100 boathouses stood. These were the summerhouses of various social clubs and prominent Pottsville residents. (Courtesy of HSSC.)

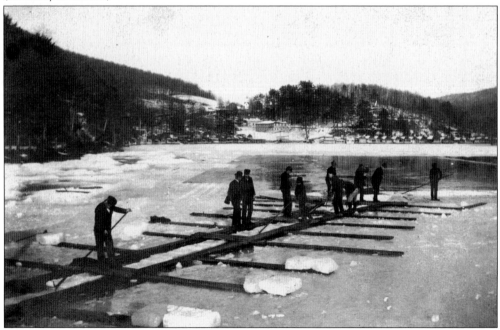

Harvesting ice was a necessary winter activity in various parts of the river and the canal. In this February 17, 1906, photograph, men use hand tools to cut large chunks of ice from Tumbling Run. (Courtesy of HSSC.)

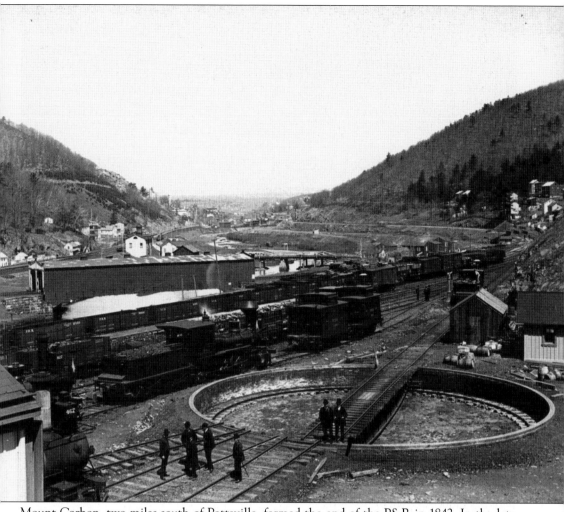

Mount Carbon, two miles south of Pottsville, formed the end of the P&R in 1842. In the late 1800s, the Pennsylvania Railroad also extended a branch to Pottsville. The 1890 photograph above shows the Mount Carbon yards and turntable of the Pennsylvania Railroad. To the left, just beyond the trains, is the covered bridge that linked the two railroads. (Courtesy of HSSC.)

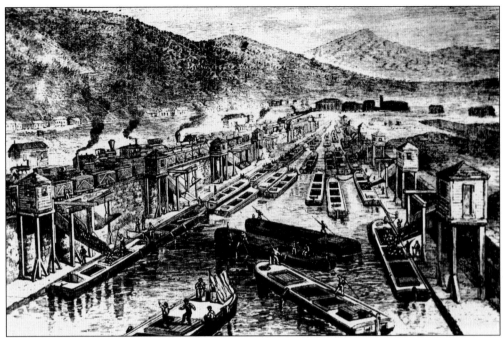

The Schuylkill Canal began in Port Carbon, located just northeast of Pottsville, and thus was the site of lock 1, known as Firth Lock. This early illustration shows how coal was loaded from trains into the waiting boats. In 1853, this section of the canal, including the loading docks, was the first to be abandoned as a result of coal silt clogging the waterway. (Courtesy of HSSC.)

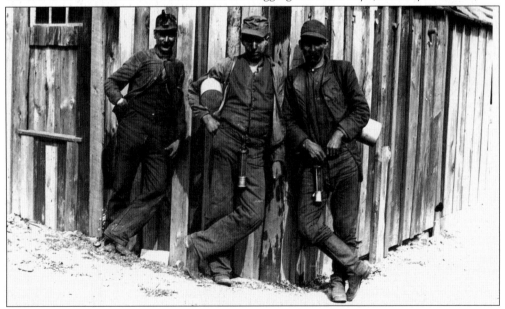

York Farm Colliery was a major coal yard in 1891 when this photograph was taken. It was established in 1835 by Philadelphia book publisher Henry C. Carey, who became a pioneer in the coal industry. He and his partners invested $100,000 to build a mine 3,000 feet deep, and in 1837, 33,000 tons of coal were sent out. Later a mile-long railroad transported coal to a canal landing. (Courtesy of HSSC.)

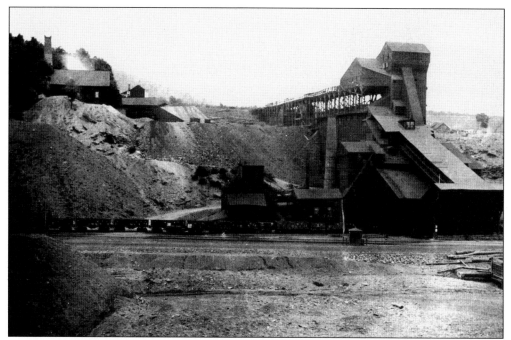

St. Clair, just north of Pottsville, had extensive deposits of coal. Here the Eagle Colliery is seen before it was destroyed by fire in 1878. Collieries often had a number of structures, including chutes and iron plates where coal was broken with hammers and sized. (Courtesy of HSSC.)

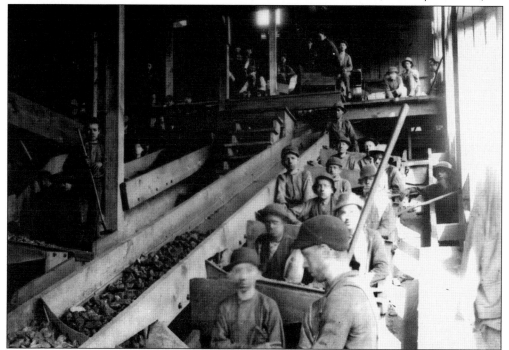

Before child labor laws, breaker boys worked in anthracite coal mines to handpick slate and rocks from the coal. Some started as young as age 10. They worked 12 to 14 hours a day in breakers, dark buildings where coal was crushed and sorted by size. (Courtesy of HSSC.)

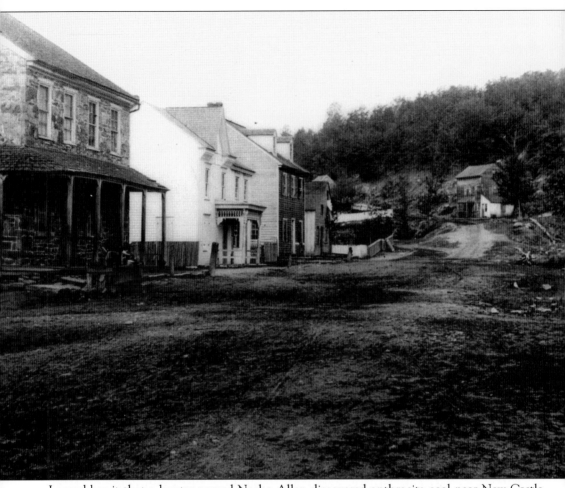

Legend has it that a hunter named Necho Allen discovered anthracite coal near New Castle Township, pictured above. In 1790, he reportedly fell asleep by his campfire and awoke to find the hillside aglow. He had ignited an outcropping of coal, a discovery that would forever change and define the Schuylkill River region. (Courtesy of HSSC.)

About the Schuylkill River National and State Heritage Area

The Schuylkill River National and State Heritage Area in southeastern Pennsylvania celebrates the Schuylkill River corridor as one of America's most significant cultural and industrial regions. Here people, places, and events played a major role in the American Revolution, Industrial Revolution, and environmental revolution.

The boundaries of the heritage area cover the Schuylkill River watershed in Schuylkill, Berks, Chester, Montgomery, and Philadelphia Counties. This region is home to over 3.2 million people, approximately 1.75 million of whom draw their drinking water directly from the river.

The Schuylkill River watershed was designated as a Pennsylvania heritage area by the Pennsylvania Department of Conservation and Natural Resources in 1995 and as a national heritage area in 2000. A national heritage area is a place selected by the United States Congress for its natural, cultural, historic, and recreational resources, which combine to form a cohesive, nationally distinctive landscape.

The Schuylkill River National and State Heritage Area uses conservation, education, cultural and historic preservation, recreation, and tourism as tools for community revitalization and economic development. To learn more, visit the Schuylkill River National and State Heritage Area Web site.

ACROSS AMERICA, PEOPLE ARE DISCOVERING SOMETHING WONDERFUL. *THEIR HERITAGE.*

Arcadia Publishing is the leading local history publisher in the United States. With more than 3,000 titles in print and hundreds of new titles released every year, Arcadia has extensive specialized experience chronicling the history of communities and celebrating America's hidden stories, bringing to life the people, places, and events from the past. To discover the history of other communities across the nation, please visit:

www.arcadiapublishing.com

Customized search tools allow you to find regional history books about the town where you grew up, the cities where your friends and family live, the town where your parents met, or even that retirement spot you've been dreaming about.